For Hannah and Sebastian.

An Unreliable History of Tattoos is © Nobrow 2016.

This is a first edition published in 2016 by
Nobrow Ltd. 62 Great Eastern Street, London, EC2A 3QR.

Text and illustrations © Paul Thomas 2016.
Paul Thomas has asserted his right under the Copyright,
Designs and Patents Act, 1988, to be identified as
the Author and Illustrator of this Work.

Published in the US by Nobrow (US) Inc.

Printed in Latvia on FSC assured paper.
ISBN: 978-1-910620-04-5

Order from www.nobrow.net

An Unreliable History of Tattoos

PAUL THOMAS

NOBROW

London – New York

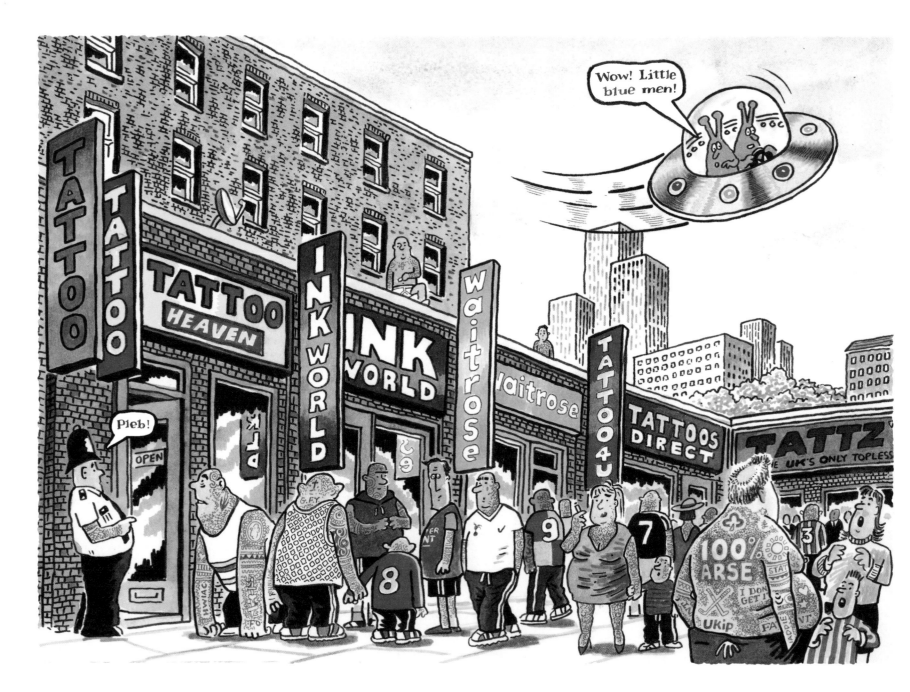

The popularity of tattoos has fluctuated over the centuries. They are currently very much in fashion. There are now more tattoo studios in most British high streets than there are coffee shops. Once the disfiguring mark of the outsider, the sheer ubiquity of tattoos has reduced their ability to shock. They rarely fail to both fascinate and appall.

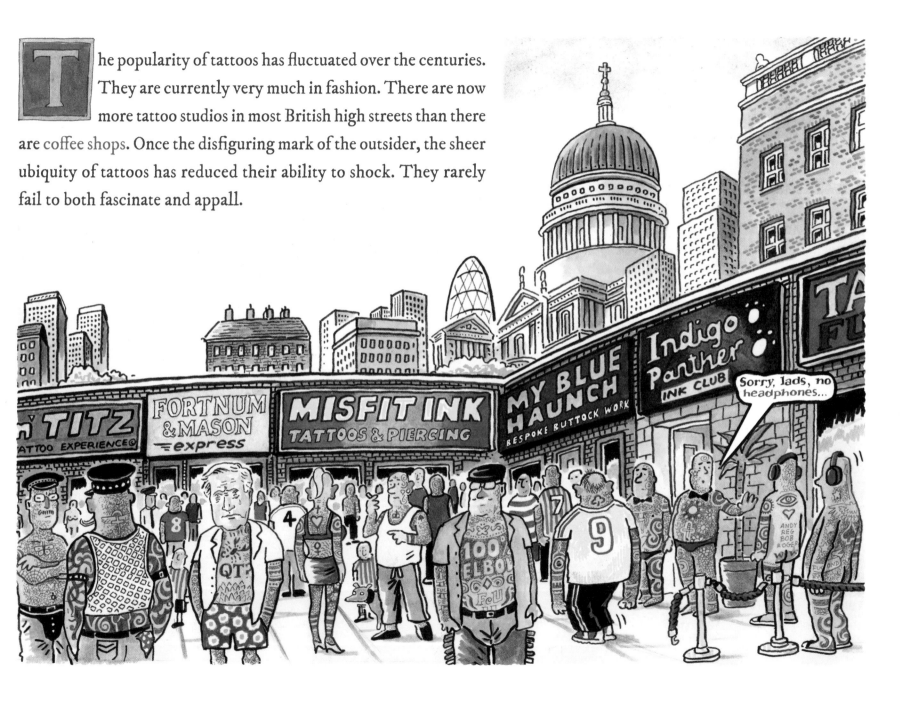

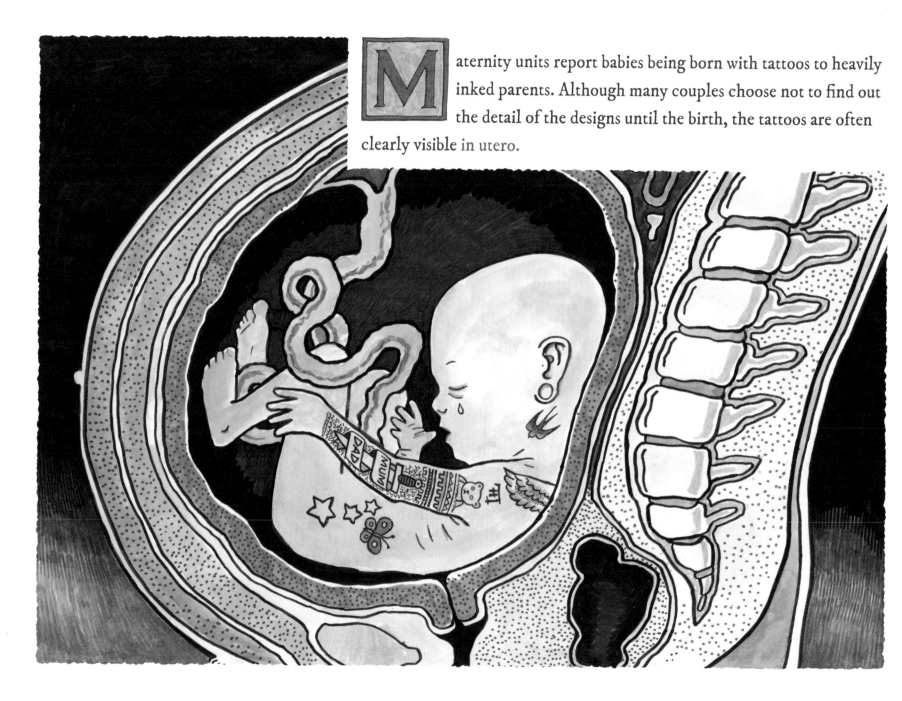

Maternity units report babies being born with tattoos to heavily inked parents. Although many couples choose not to find out the detail of the designs until the birth, the tattoos are often clearly visible in utero.

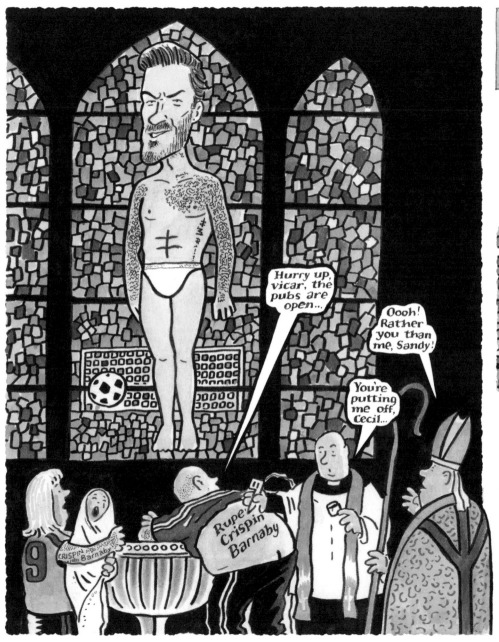

Traditional christening services are being replaced by ceremonies where the newborn's name will be tattooed on some part of one or both parents' anatomy. Their choice of decorative script is, as one archbishop observed, the closest some of these people will ever get to a font.

So, as our society and its cultural and sporting icons drown in a sea of ink, it is time to examine the phenomenon of tattoos. What lessons can we learn from their history? Can we halt their inexorable spread? Do we even want to? Maybe we'd be better off just getting tattooed ourselves, taking our tops off and swigging cider from a plastic bottle down by the war memorial.

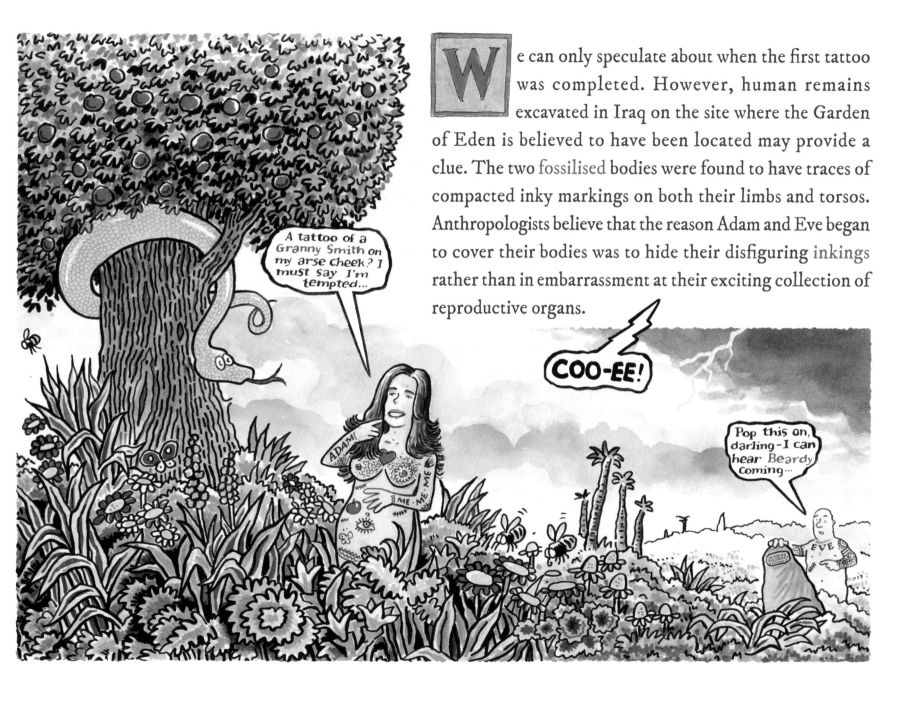

We can only speculate about when the first tattoo was completed. However, human remains excavated in Iraq on the site where the Garden of Eden is believed to have been located may provide a clue. The two fossilised bodies were found to have traces of compacted inky markings on both their limbs and torsos. Anthropologists believe that the reason Adam and Eve began to cover their bodies was to hide their disfiguring inkings rather than in embarrassment at their exciting collection of reproductive organs.

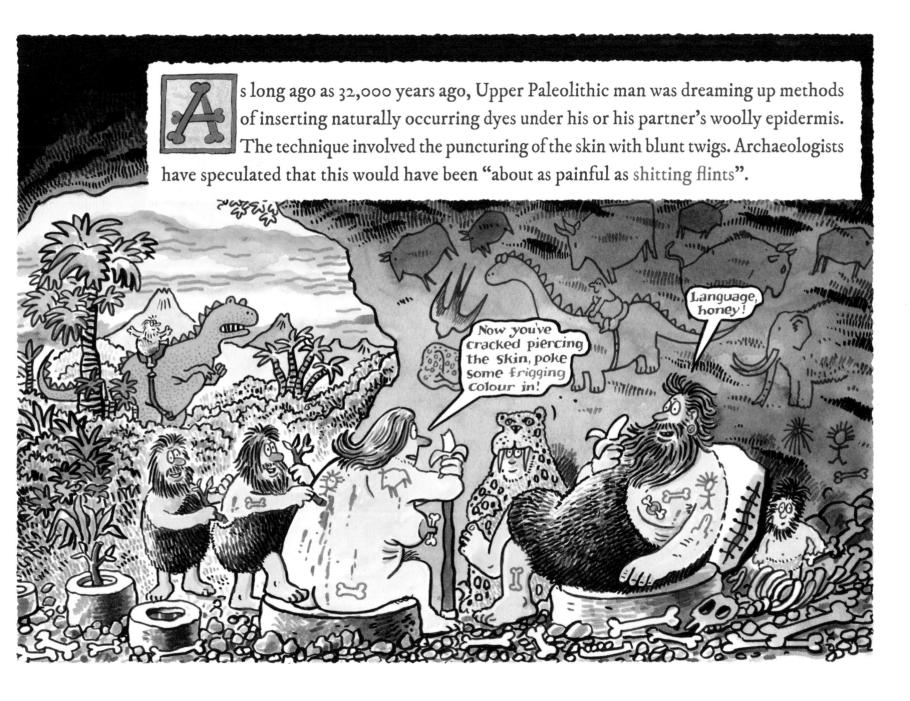

As long ago as 32,000 years ago, Upper Paleolithic man was dreaming up methods of inserting naturally occurring dyes under his or his partner's woolly epidermis. The technique involved the puncturing of the skin with blunt twigs. Archaeologists have speculated that this would have been "about as painful as shitting flints".

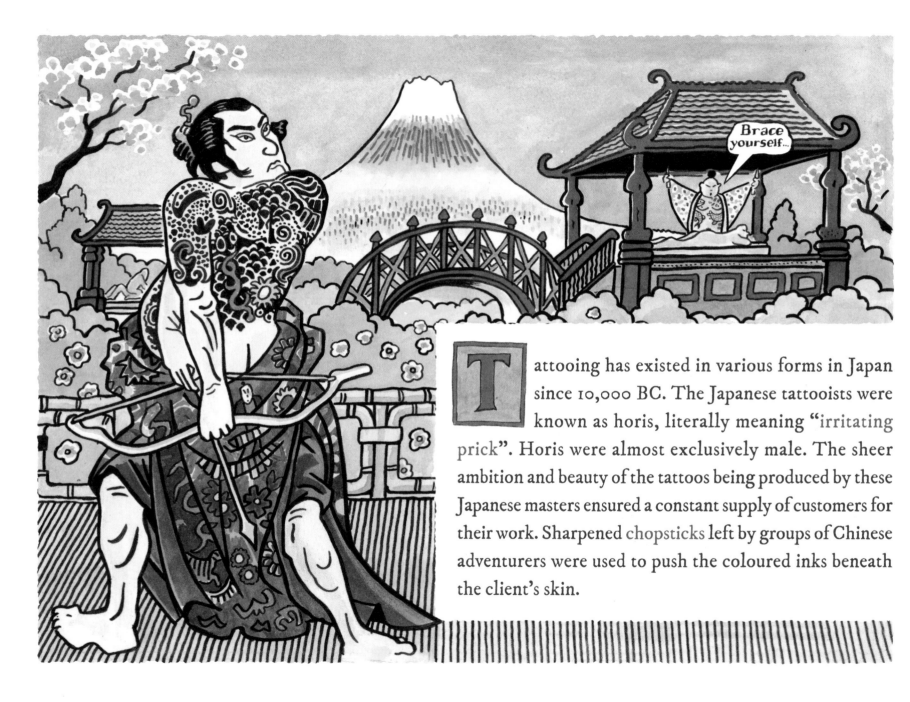

attooing has existed in various forms in Japan since 10,000 BC. The Japanese tattooists were known as horis, literally meaning "irritating prick". Horis were almost exclusively male. The sheer ambition and beauty of the tattoos being produced by these Japanese masters ensured a constant supply of customers for their work. Sharpened chopsticks left by groups of Chinese adventurers were used to push the coloured inks beneath the client's skin.

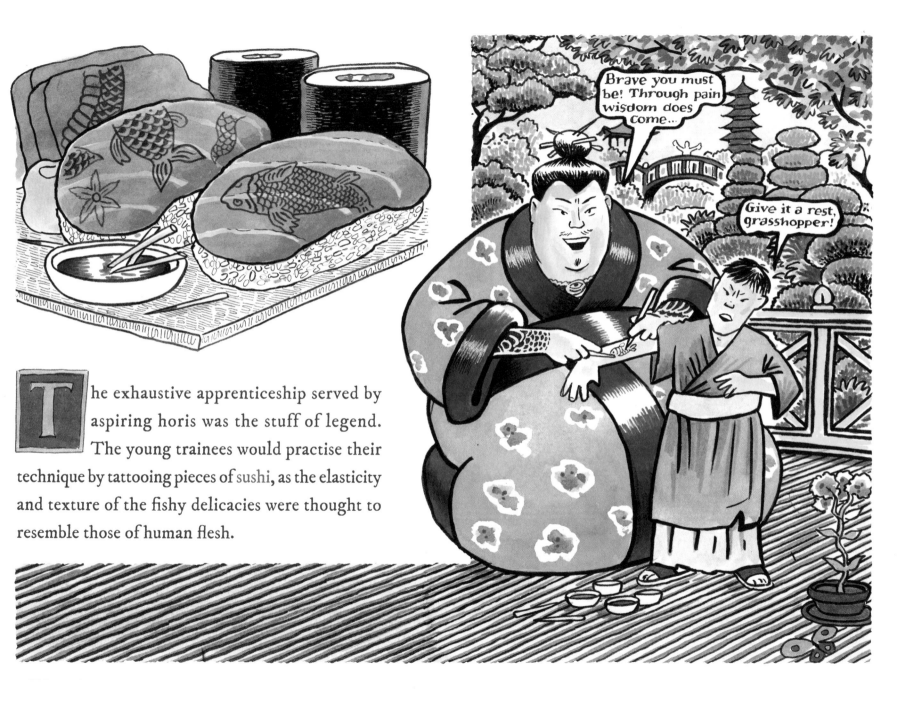

The exhaustive apprenticeship served by aspiring horis was the stuff of legend. The young trainees would practise their technique by tattooing pieces of sushi, as the elasticity and texture of the fishy delicacies were thought to resemble those of human flesh.

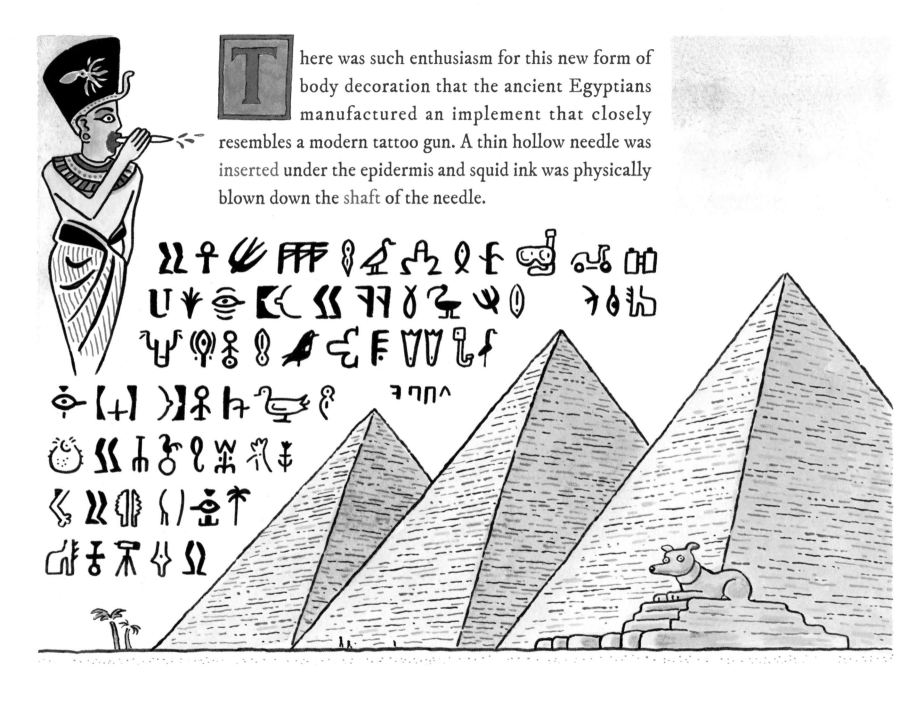

There was such enthusiasm for this new form of body decoration that the ancient Egyptians manufactured an implement that closely resembles a modern tattoo gun. A thin hollow needle was inserted under the epidermis and squid ink was physically blown down the shaft of the needle.

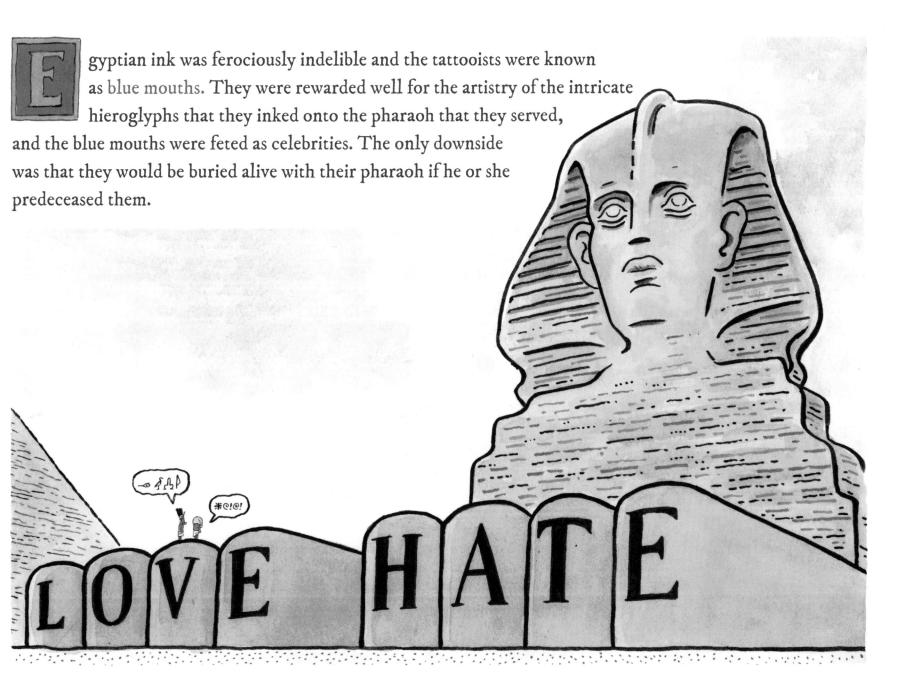

Egyptian ink was ferociously indelible and the tattooists were known as blue mouths. They were rewarded well for the artistry of the intricate hieroglyphs that they inked onto the pharaoh that they served, and the blue mouths were feted as celebrities. The only downside was that they would be buried alive with their pharaoh if he or she predeceased them.

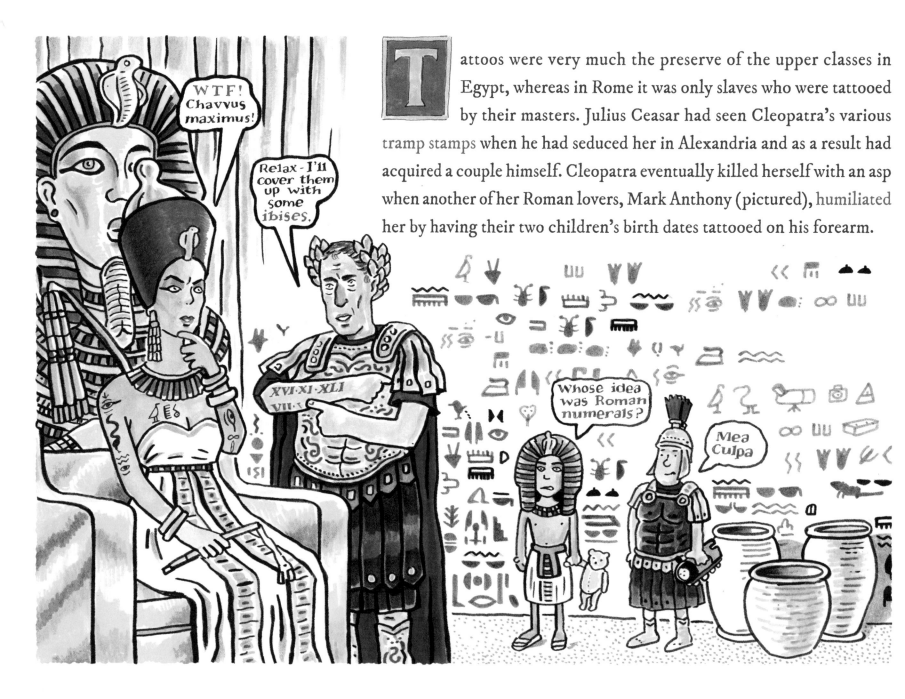

Tattoos were very much the preserve of the upper classes in Egypt, whereas in Rome it was only slaves who were tattooed by their masters. Julius Ceasar had seen Cleopatra's various tramp stamps when he had seduced her in Alexandria and as a result had acquired a couple himself. Cleopatra eventually killed herself with an asp when another of her Roman lovers, Mark Anthony (pictured), humiliated her by having their two children's birth dates tattooed on his forearm.

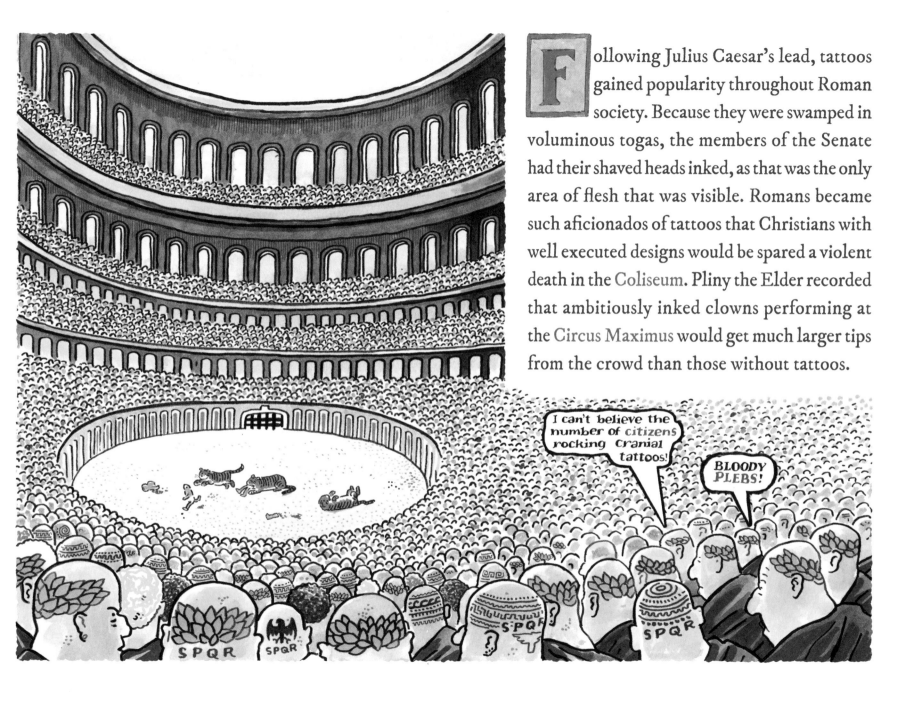

Following Julius Caesar's lead, tattoos gained popularity throughout Roman society. Because they were swamped in voluminous togas, the members of the Senate had their shaved heads inked, as that was the only area of flesh that was visible. Romans became such aficionados of tattoos that Christians with well executed designs would be spared a violent death in the Coliseum. Pliny the Elder recorded that ambitiously inked clowns performing at the Circus Maximus would get much larger tips from the crowd than those without tattoos.

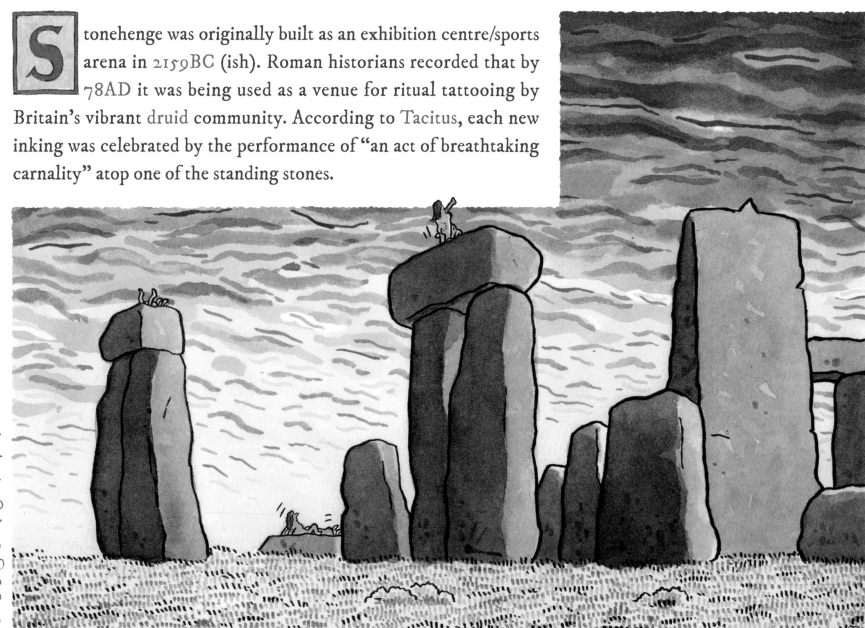

Stonehenge was originally built as an exhibition centre/sports arena in 2159BC (ish). Roman historians recorded that by 78AD it was being used as a venue for ritual tattooing by Britain's vibrant druid community. According to Tacitus, each new inking was celebrated by the performance of "an act of breathtaking carnality" atop one of the standing stones.

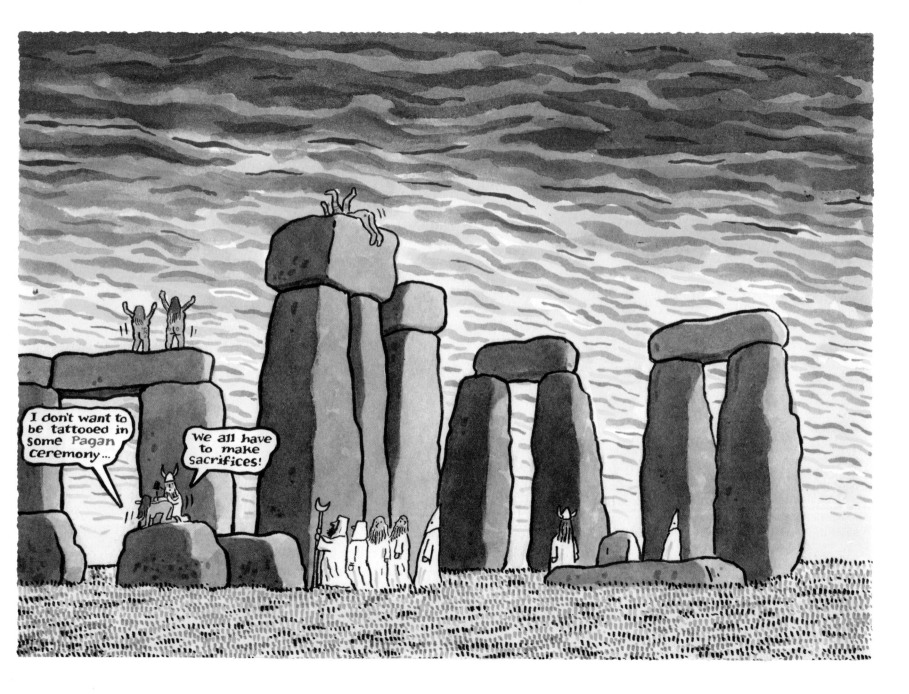

In Britain in 60AD, Boudica and the Iceni tribe painted themselves with a blue dye before going into battle against the Roman invaders. Frustrated by the dye's impermanence under battle conditions, the Iceni began to insert it beneath their skin with wooden or iron spikes. The procedure became known as woad processing. Further north, in Scotland, the Picts were also injecting themselves with a blue dye mixed with a primitive form of heroin. According to recent Home Office statistics, this practice continues to be popular across Britain to this day.

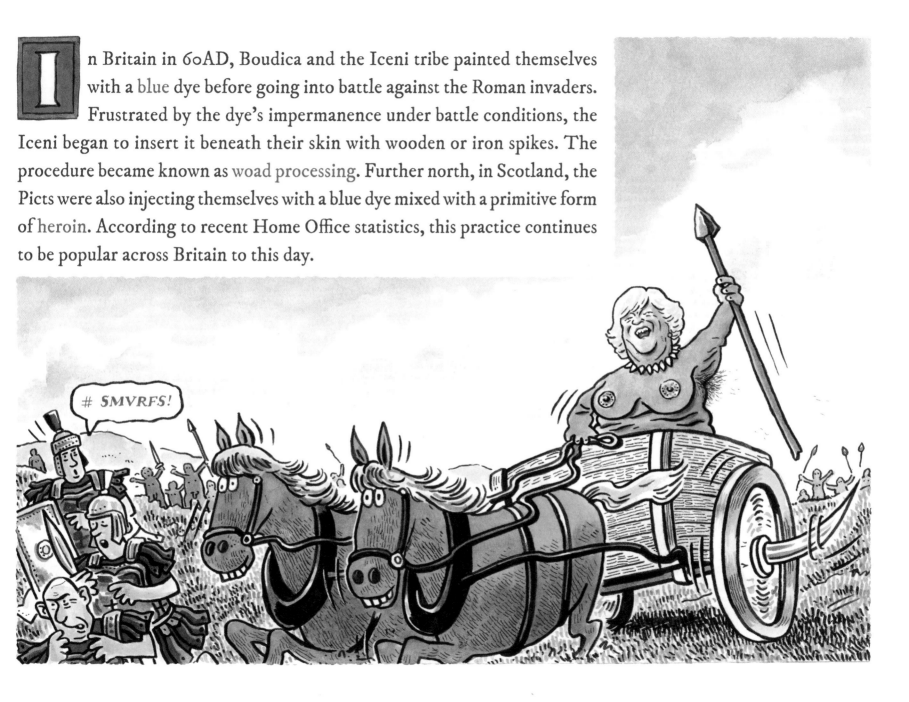

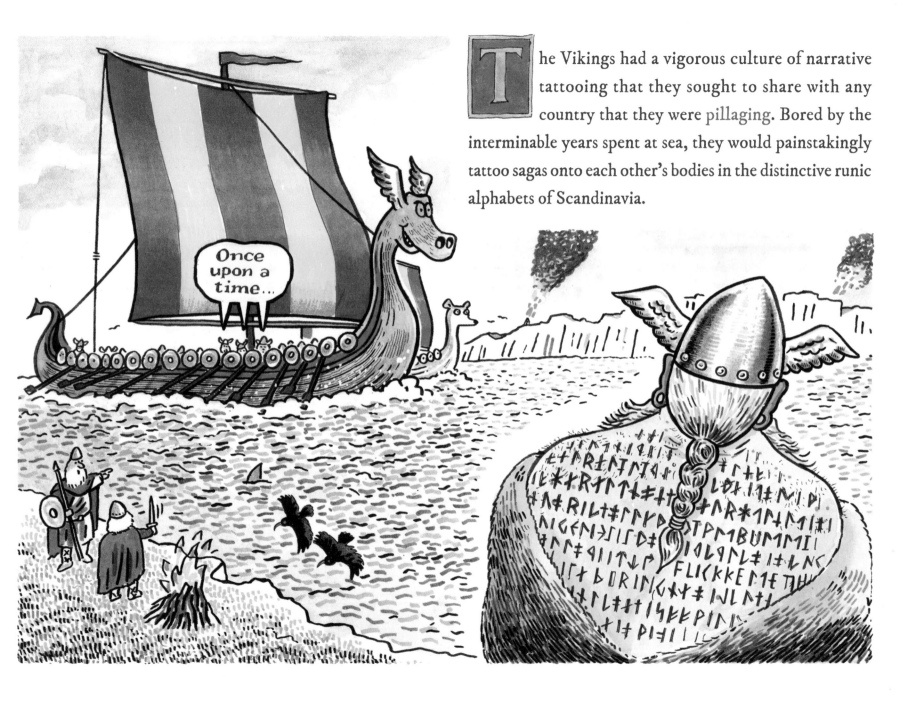

The Vikings had a vigorous culture of narrative tattooing that they sought to share with any country that they were pillaging. Bored by the interminable years spent at sea, they would painstakingly tattoo sagas onto each other's bodies in the distinctive runic alphabets of Scandinavia.

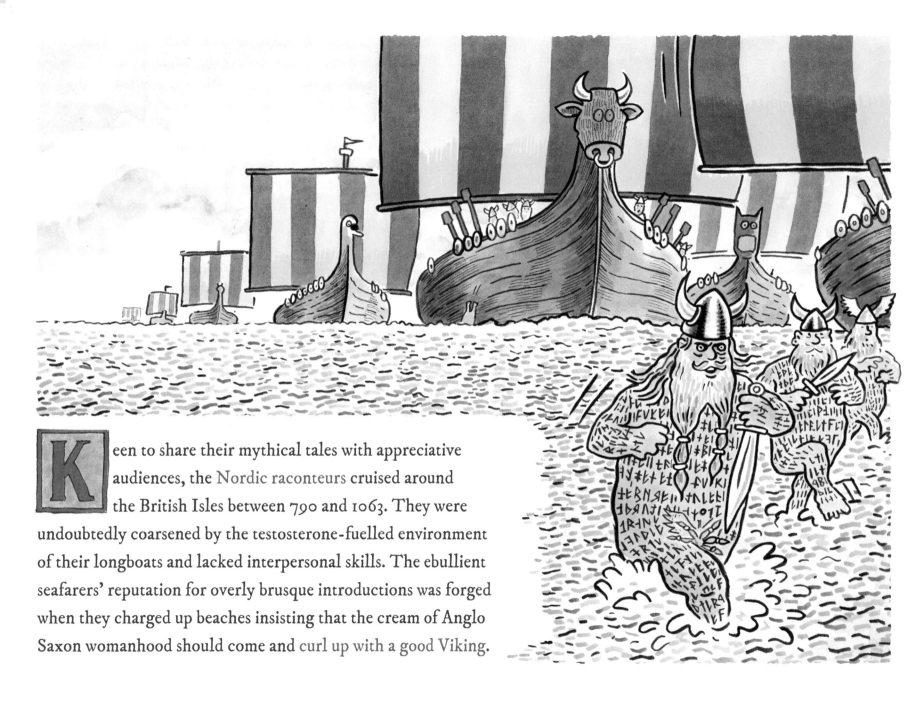

Keen to share their mythical tales with appreciative audiences, the Nordic raconteurs cruised around the British Isles between 790 and 1063. They were undoubtedly coarsened by the testosterone-fuelled environment of their longboats and lacked interpersonal skills. The ebullient seafarers' reputation for overly brusque introductions was forged when they charged up beaches insisting that the cream of Anglo Saxon womanhood should come and curl up with a good Viking.

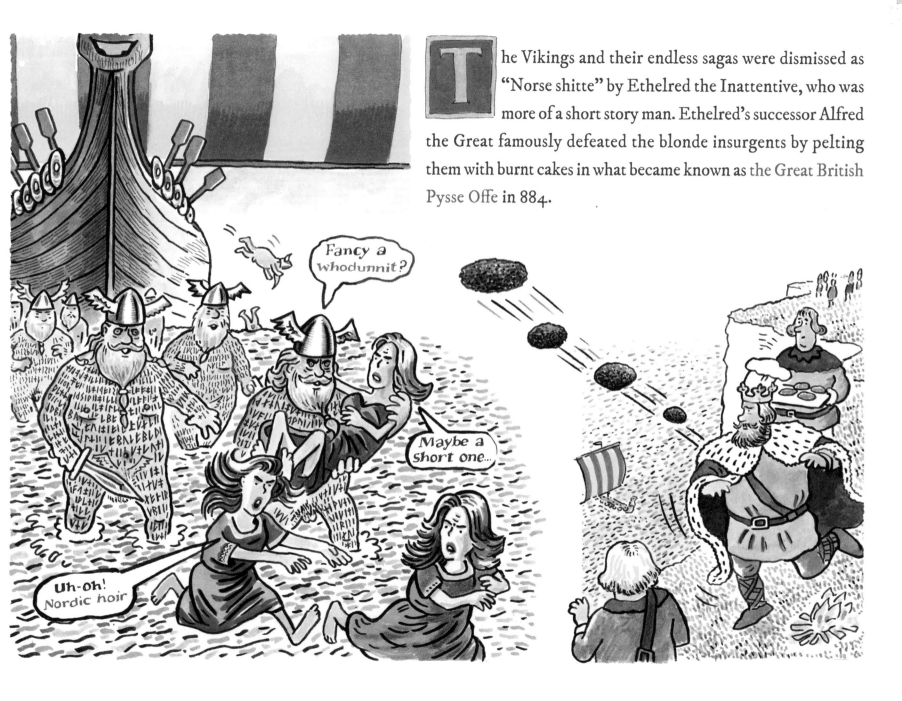

The Vikings and their endless sagas were dismissed as "Norse shitte" by Ethelred the Inattentive, who was more of a short story man. Ethelred's successor Alfred the Great famously defeated the blonde insurgents by pelting them with burnt cakes in what became known as the Great British Pysse Offe in 884.

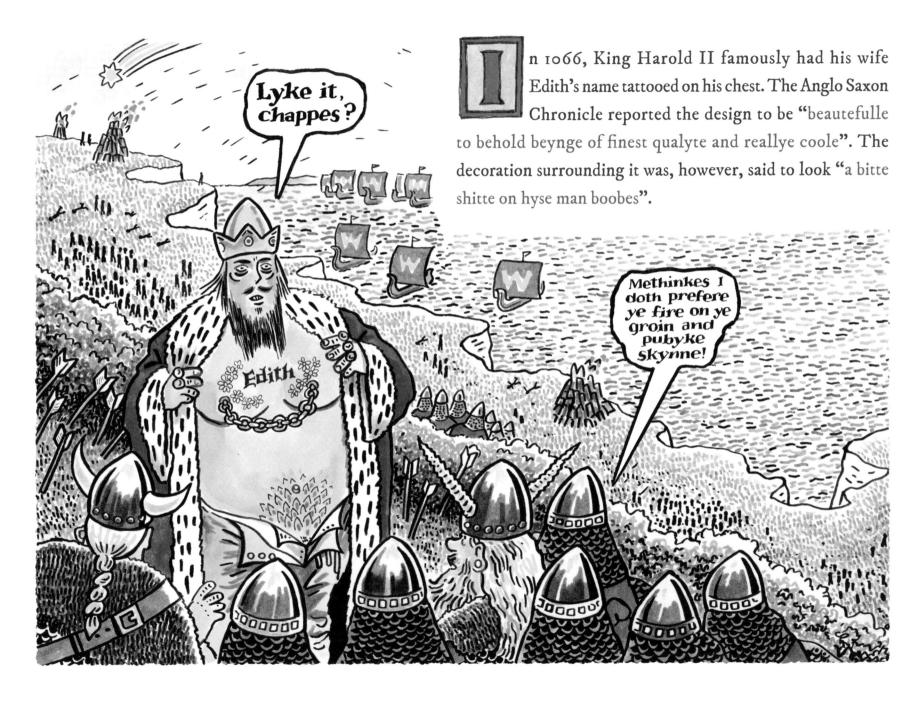

In 1066, King Harold II famously had his wife Edith's name tattooed on his chest. The Anglo Saxon Chronicle reported the design to be "beautefulle to behold beynge of finest qualyte and reallye coole". The decoration surrounding it was, however, said to look "a bitte shitte on hyse man boobes".

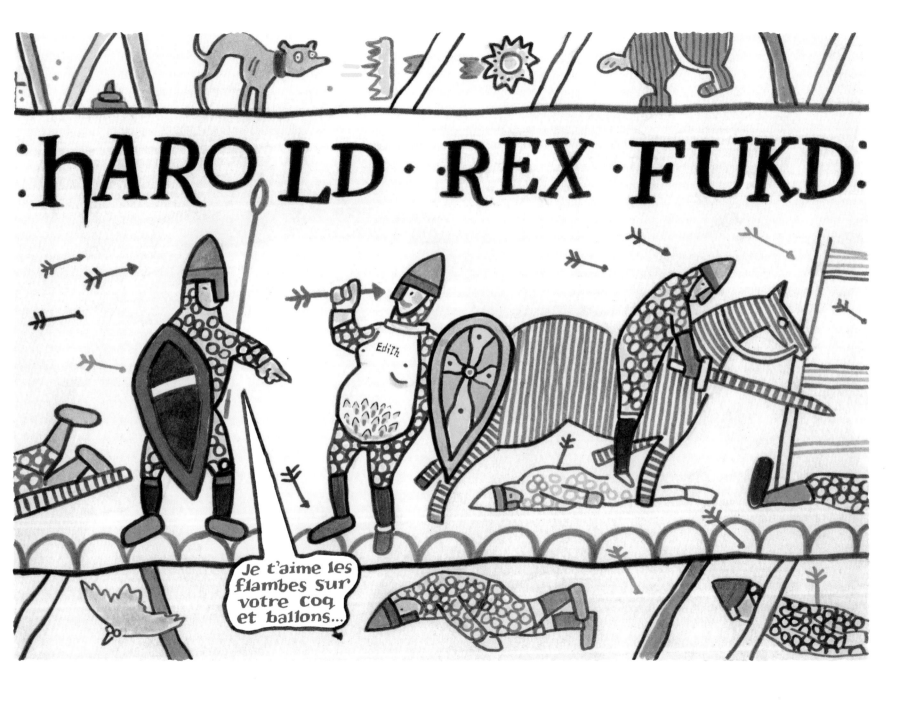

William the Conqueror had a visceral hatred of tattoos, believing them to be both trivial and disfiguring. In his foreword to the Domesday Book, which catalogued "Everye mark on everye man in England", William declared them to be the stamp of "Les wankeres et les chavves". The king also introduced a crippling ink tax on any of his subjects who dared to continue the practice. Nobody did.

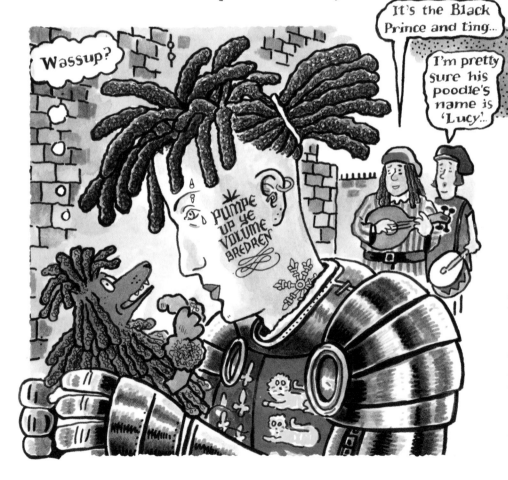

Name: Richard Bluetooth

Age: 34 years-ish

Married to: Marye

Offspring: Yarp (2)

Address: Ye Olde Swampe, Slurry Lane, Putney SW15

Distinguishinge markes:

A badly drawne unicorn on hyse arm (left) and 'Marye' on hyse chest. Also a rubbishe Swallow on his necke that lookes more like a swift

Wassup?

It's the Black Prince and ting...

I'm pretty sure his poodle's name is 'Lucy'...

PUMPE UP YE VOLUME BREDREN

Apart from Richard I, who had a lion inked over his heart on a stag weekend in Jerusalem, the next royal to be tattooed was Edward the Black Prince. The pubescent prince had a prominent facial design as an act of youthful rebellion after being punished for allowing minstrels to play too loudly in his bed chamber at night. The Black Prince was credited with popularising reggae in his father King Edward's court. A century later, the Plantagenet Prince Buster introduced Ska music and pork pie hats to King Richard III.

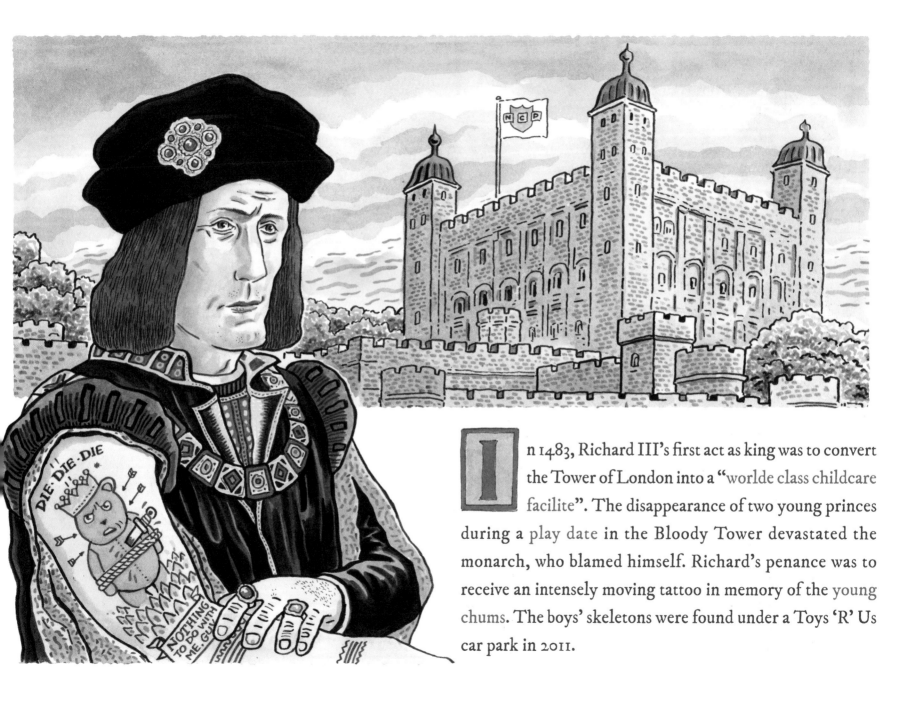

In 1483, Richard III's first act as king was to convert the Tower of London into a "worlde class childcare facilite". The disappearance of two young princes during a play date in the Bloody Tower devastated the monarch, who blamed himself. Richard's penance was to receive an intensely moving tattoo in memory of the young chums. The boys' skeletons were found under a Toys 'R' Us car park in 2011.

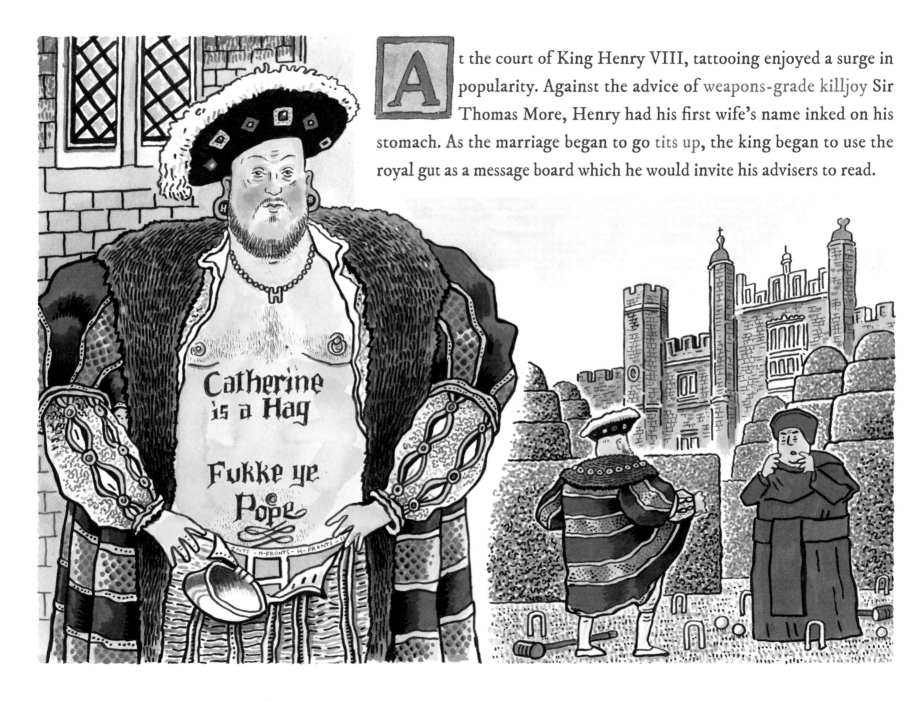

At the court of King Henry VIII, tattooing enjoyed a surge in popularity. Against the advice of weapons-grade killjoy Sir Thomas More, Henry had his first wife's name inked on his stomach. As the marriage began to go tits up, the king began to use the royal gut as a message board which he would invite his advisers to read.

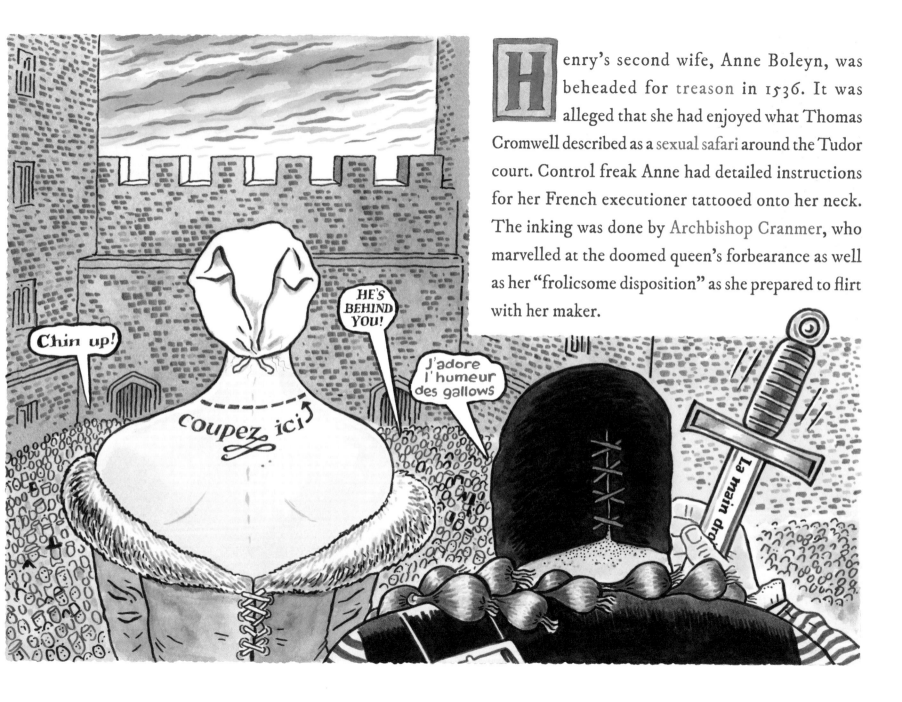

Henry's second wife, Anne Boleyn, was beheaded for treason in 1536. It was alleged that she had enjoyed what Thomas Cromwell described as a sexual safari around the Tudor court. Control freak Anne had detailed instructions for her French executioner tattooed onto her neck. The inking was done by Archbishop Cranmer, who marvelled at the doomed queen's forbearance as well as her "frolicsome disposition" as she prepared to flirt with her maker.

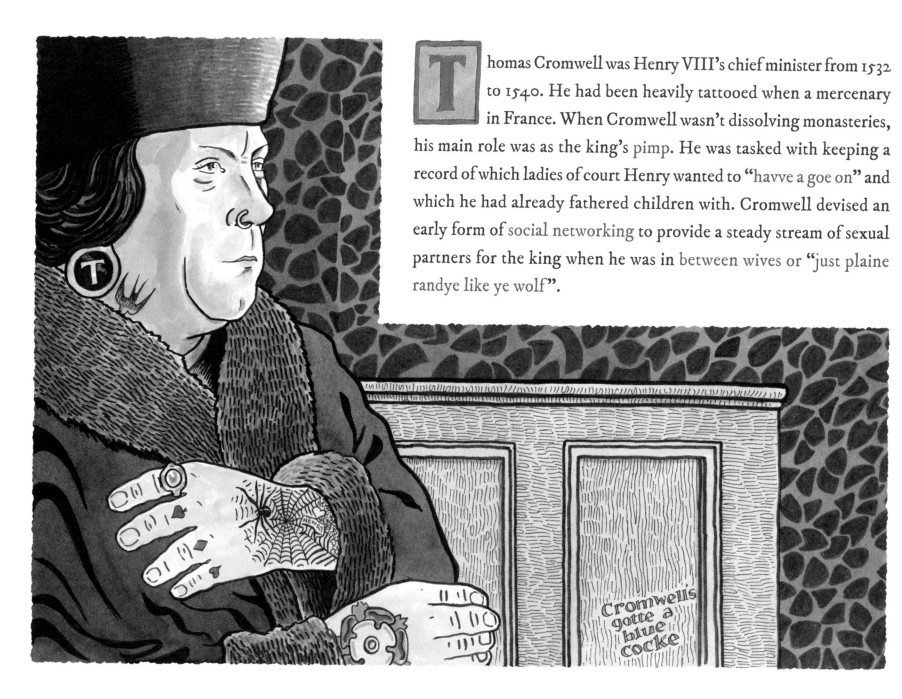

Thomas Cromwell was Henry VIII's chief minister from 1532 to 1540. He had been heavily tattooed when a mercenary in France. When Cromwell wasn't dissolving monasteries, his main role was as the king's pimp. He was tasked with keeping a record of which ladies of court Henry wanted to "havve a goe on" and which he had already fathered children with. Cromwell devised an early form of social networking to provide a steady stream of sexual partners for the king when he was in between wives or "just plaine randye like ye wolf".

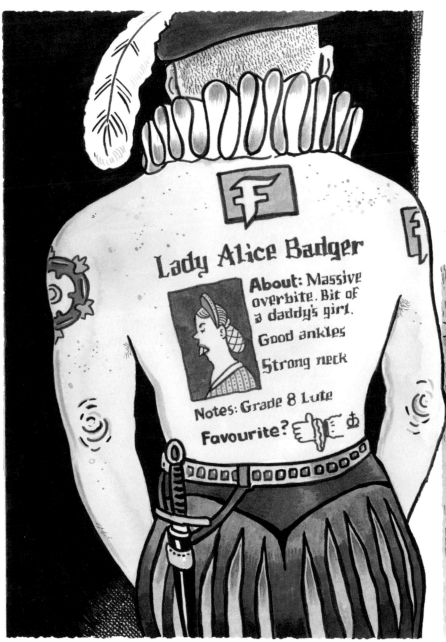

Noblemen were required to have portraits of their daughters tattooed on the backs of their male servants. These unfortunate inked wretches were known as Facebooke Pages and were sent to London to parade in front of the king. A "thumbs up" would be etched in the 'favourite' box of any lady who piqued Henry's interest. A few weeks later, this would be followed by a poke and sometimes a rather awkward beheading.

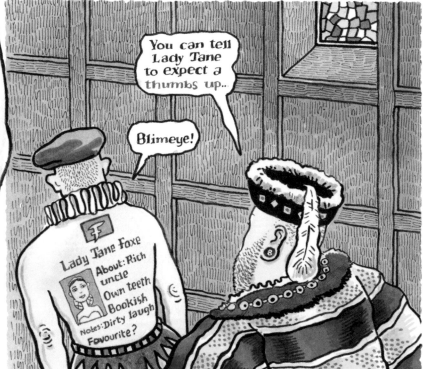

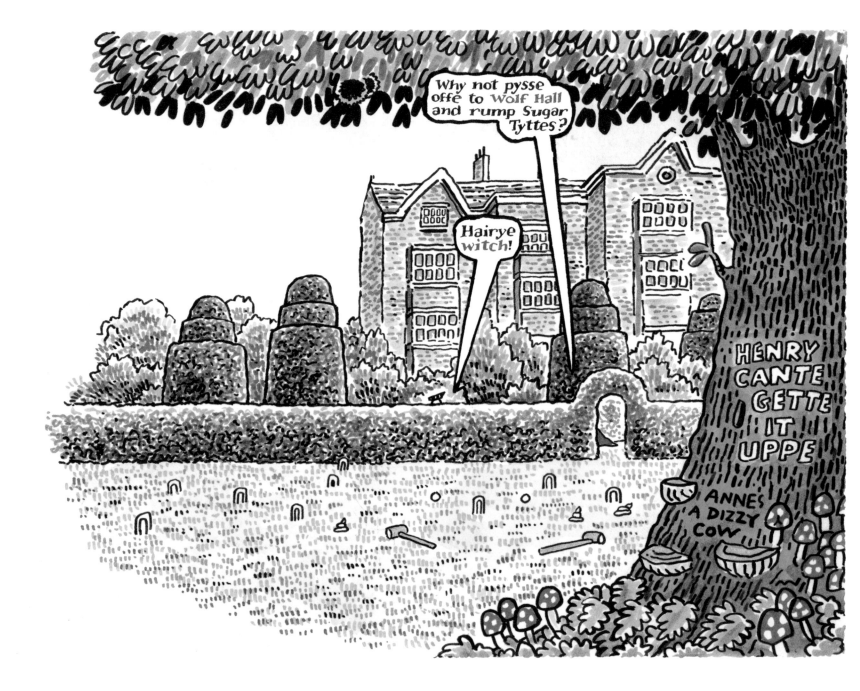

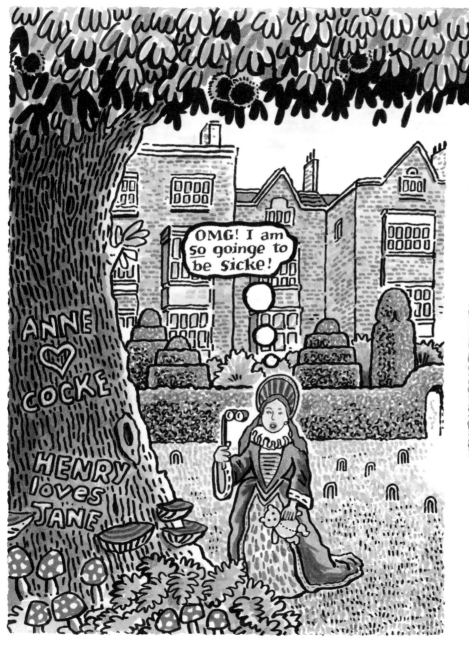

Princess Elizabeth was the product of a spectacularly broken home, and her parents Henry VIII and Anne Boleyn had both been inked at court. The sulky royal ginger nut always seemed destined to follow in their footsteps and to experiment with tattoos.

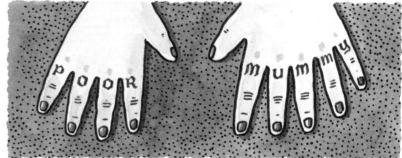

Elizabeth had inherited her mother's legendary physical deformity and had her knuckles decorated in Anne's memory at the age of 13. The tattoos were done with darning needles by a sympathetic Mistress of the Sewing Box (later hanged from a noose she was made to crochet for that very purpose).

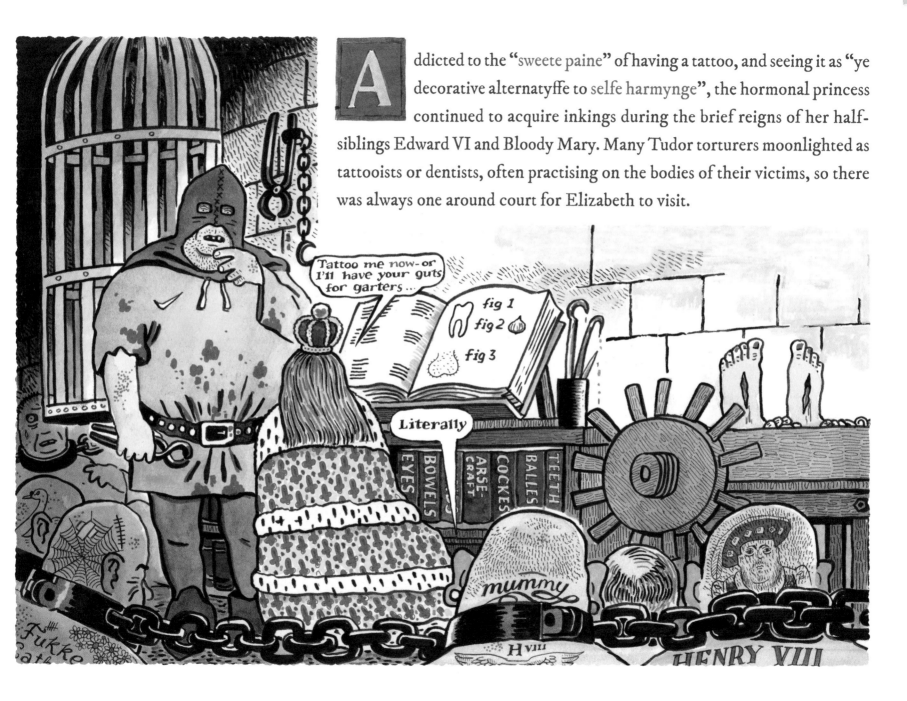

Addicted to the "sweete paine" of having a tattoo, and seeing it as "ye decorative alternatyffe to selfe harmynge", the hormonal princess continued to acquire inkings during the brief reigns of her half-siblings Edward VI and Bloody Mary. Many Tudor torturers moonlighted as tattooists or dentists, often practising on the bodies of their victims, so there was always one around court for Elizabeth to visit.

In a playful effort to secure his 14-year-old sister one of the jaw-droppingly young marriages that were popular at European courts at the time, King Edward VI decreed that Princess Elizabeth should have a new inking. The tattoo was meant to be a likeness of her intended, who was to be the 8-year-old heir apparent to the throne of France. Edward had once enjoyed a sleepover with the Dauphin at Hampton Court (and played nicely with him).

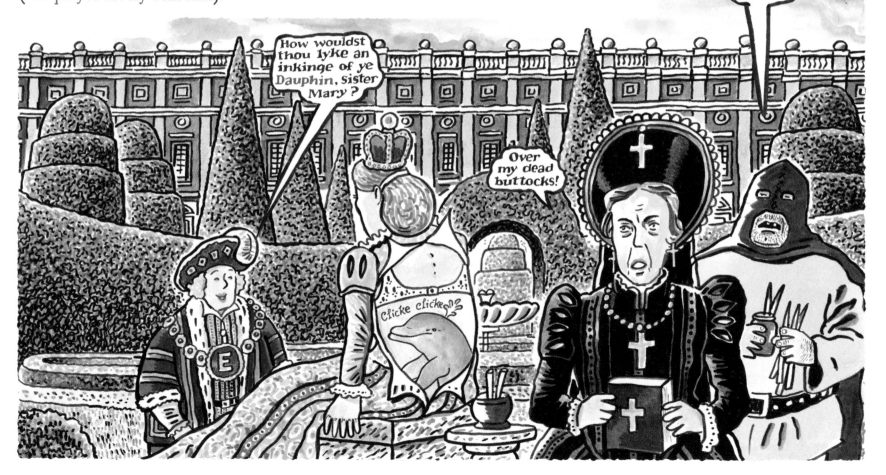

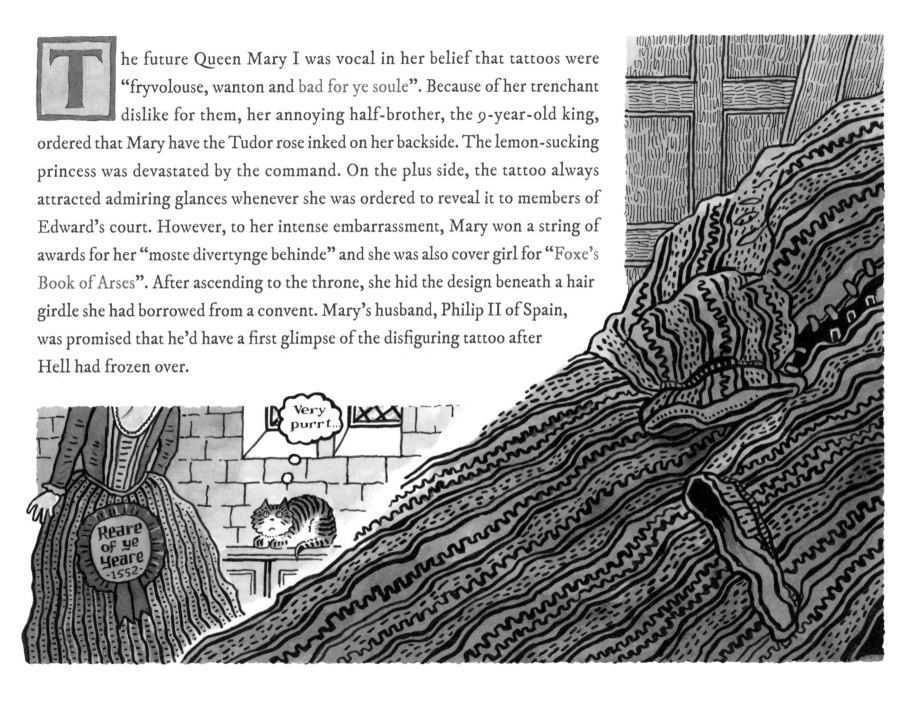

The future Queen Mary I was vocal in her belief that tattoos were "fryvolouse, wanton and bad for ye soule". Because of her trenchant dislike for them, her annoying half-brother, the 9-year-old king, ordered that Mary have the Tudor rose inked on her backside. The lemon-sucking princess was devastated by the command. On the plus side, the tattoo always attracted admiring glances whenever she was ordered to reveal it to members of Edward's court. However, to her intense embarrassment, Mary won a string of awards for her "moste divertynge behinde" and she was also cover girl for "Foxe's Book of Arses". After ascending to the throne, she hid the design beneath a hair girdle she had borrowed from a convent. Mary's husband, Philip II of Spain, was promised that he'd have a first glimpse of the disfiguring tattoo after Hell had frozen over.

Very purrt...

Reare of ye Yeare
·1552·

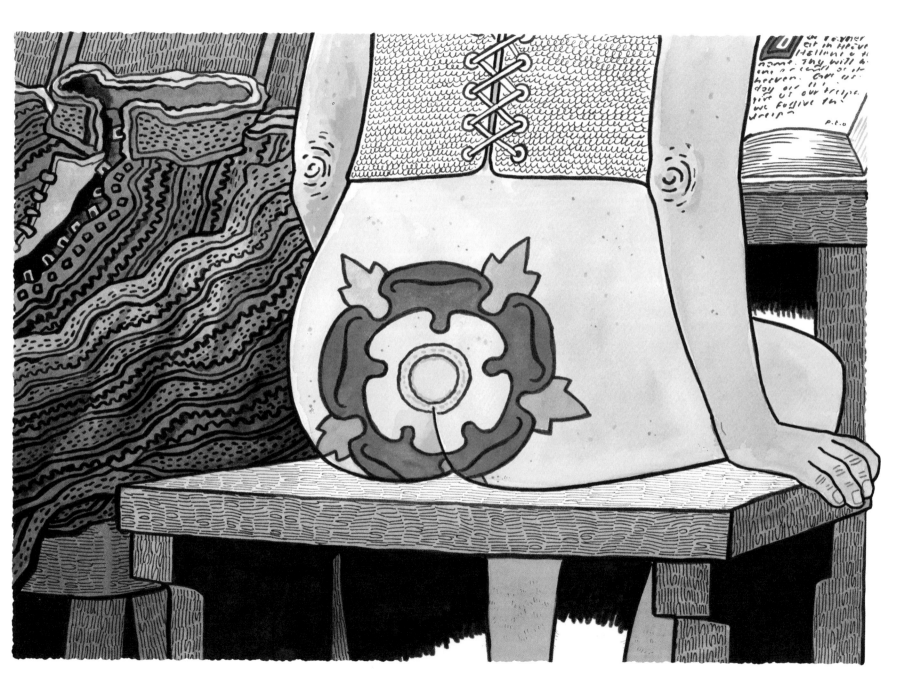

During her reign, Bloody Mary hunted down and executed every tattooist in England, such was her rage at her "moste cruelly disfigured arse cheekes". The dreadful purge became known as the Blue Murders. Upon becoming queen, Elizabeth I commemorated the inkers who had been burned to death, many of who were personal friends, by planting a sea of ceramic ultramarine poppies in the moat of the Tower of London.

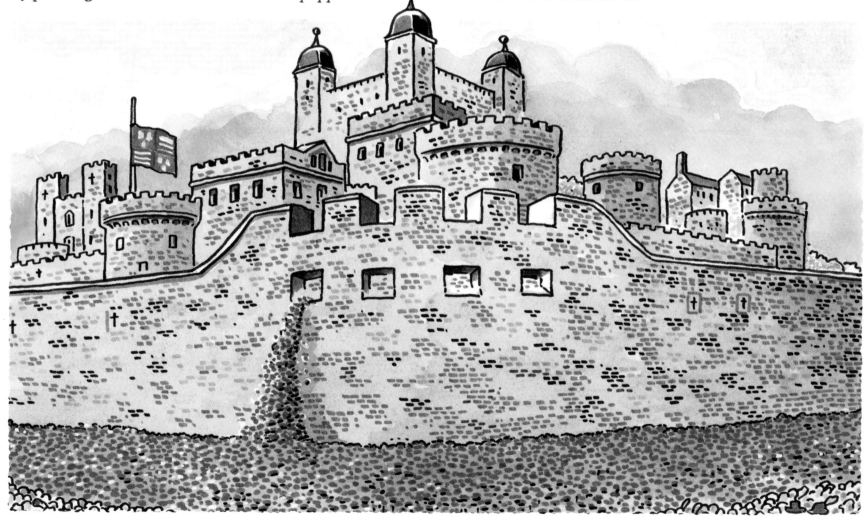

As all the English tattooists had been wiped out, Elizabeth was forced to look abroad to find a tattoo artist for her court. Likely candidates were brought to Dover with a selection of their clients to demonstrate their skill to the queen. It quickly became apparent to her advisers that the young queen was using the interviews with the tattooists merely as an excuse to chat up good-looking foreigners. After several years of flirting, she eventually settled on a dreamy, if slightly camp, young Breton called Hugo Pantoufle.

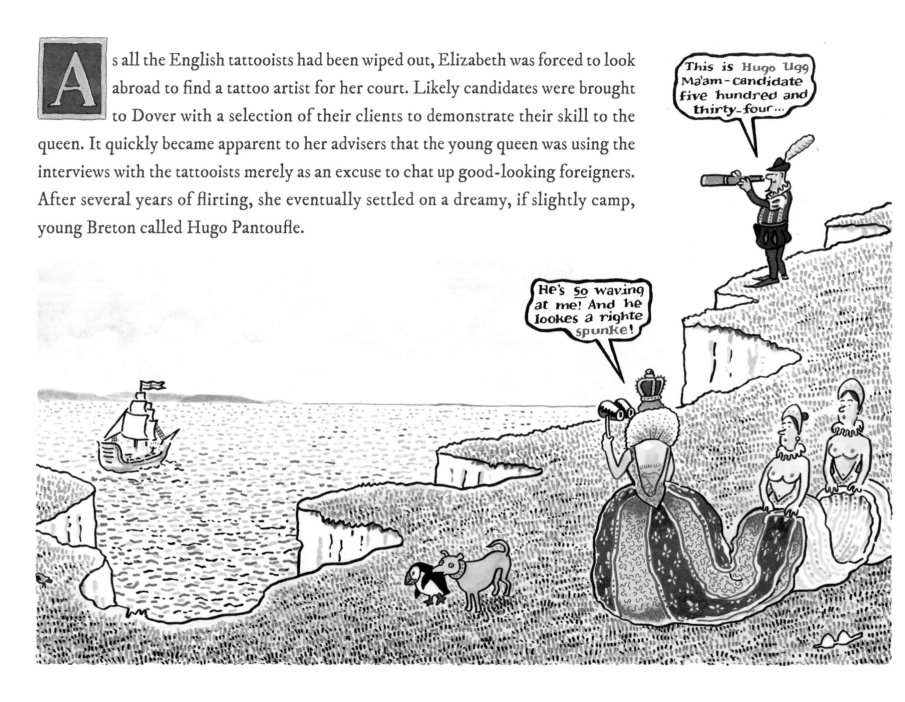

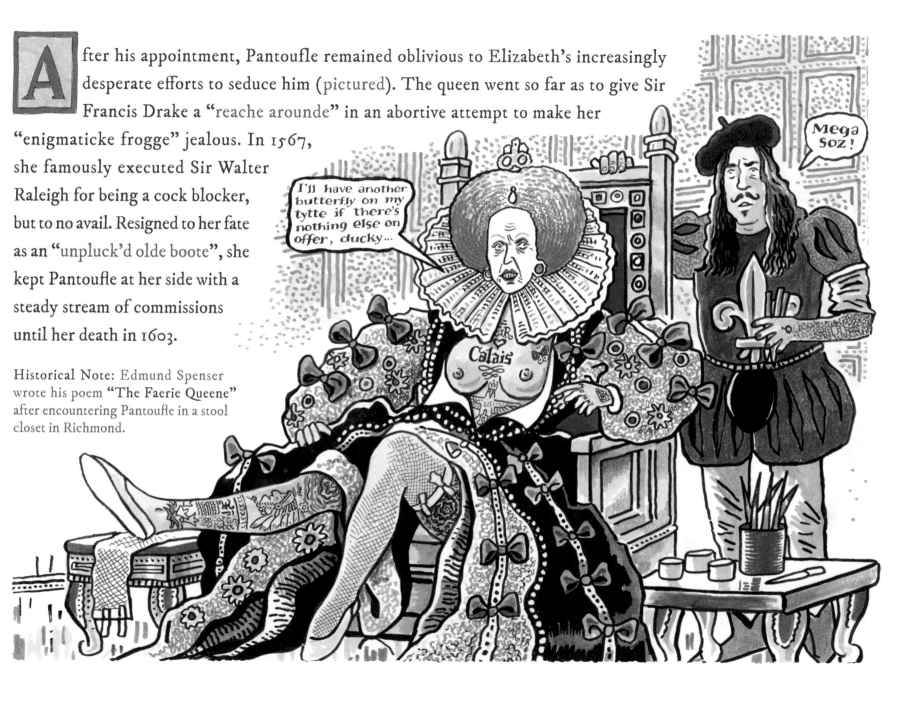

After his appointment, Pantoufle remained oblivious to Elizabeth's increasingly desperate efforts to seduce him (pictured). The queen went so far as to give Sir Francis Drake a "reache arounde" in an abortive attempt to make her "enigmaticke frogge" jealous. In 1567, she famously executed Sir Walter Raleigh for being a cock blocker, but to no avail. Resigned to her fate as an "unpluck'd olde boote", she kept Pantoufle at her side with a steady stream of commissions until her death in 1603.

Historical Note: Edmund Spenser wrote his poem "The Faerie Queene" after encountering Pantoufle in a stool closet in Richmond.

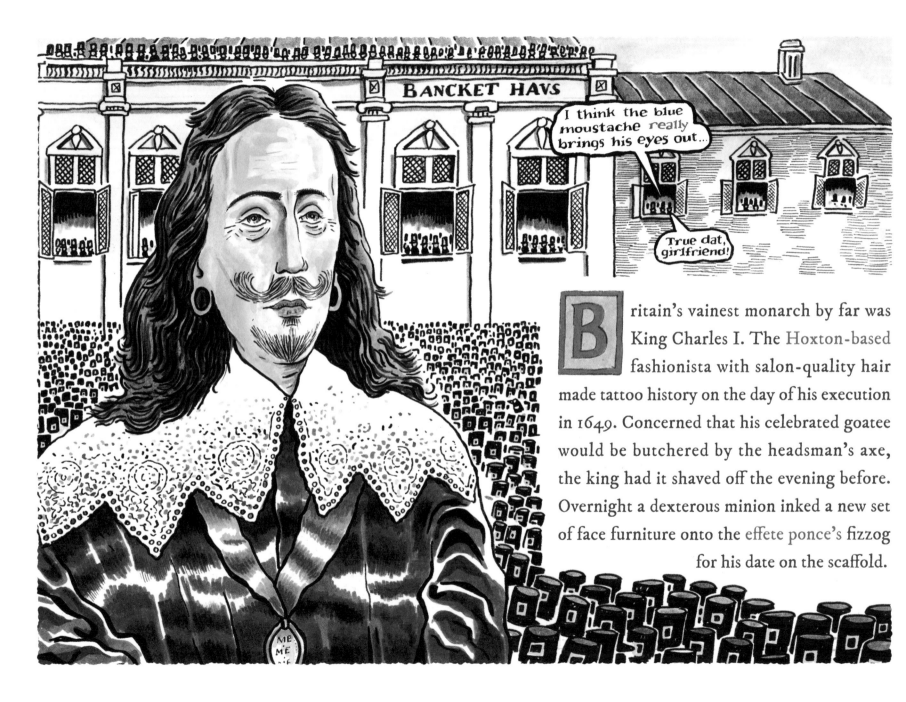

Britain's vainest monarch by far was King Charles I. The Hoxton-based fashionista with salon-quality hair made tattoo history on the day of his execution in 1649. Concerned that his celebrated goatee would be butchered by the headsman's axe, the king had it shaved off the evening before. Overnight a dexterous minion inked a new set of face furniture onto the effete ponce's fizzog for his date on the scaffold.

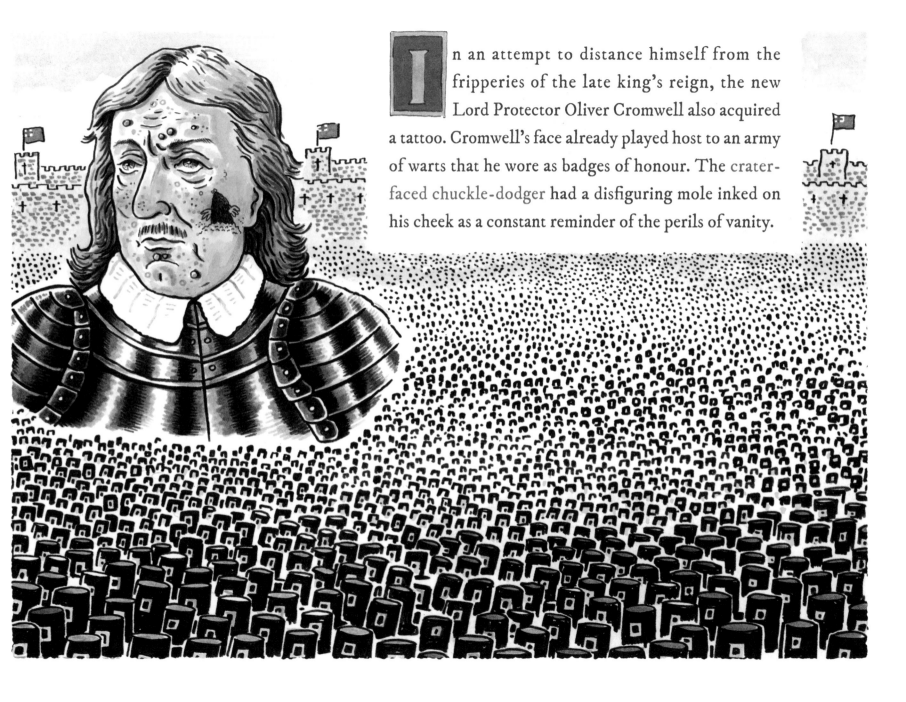

In an attempt to distance himself from the fripperies of the late king's reign, the new Lord Protector Oliver Cromwell also acquired a tattoo. Cromwell's face already played host to an army of warts that he wore as badges of honour. The crater-faced chuckle-dodger had a disfiguring mole inked on his cheek as a constant reminder of the perils of vanity.

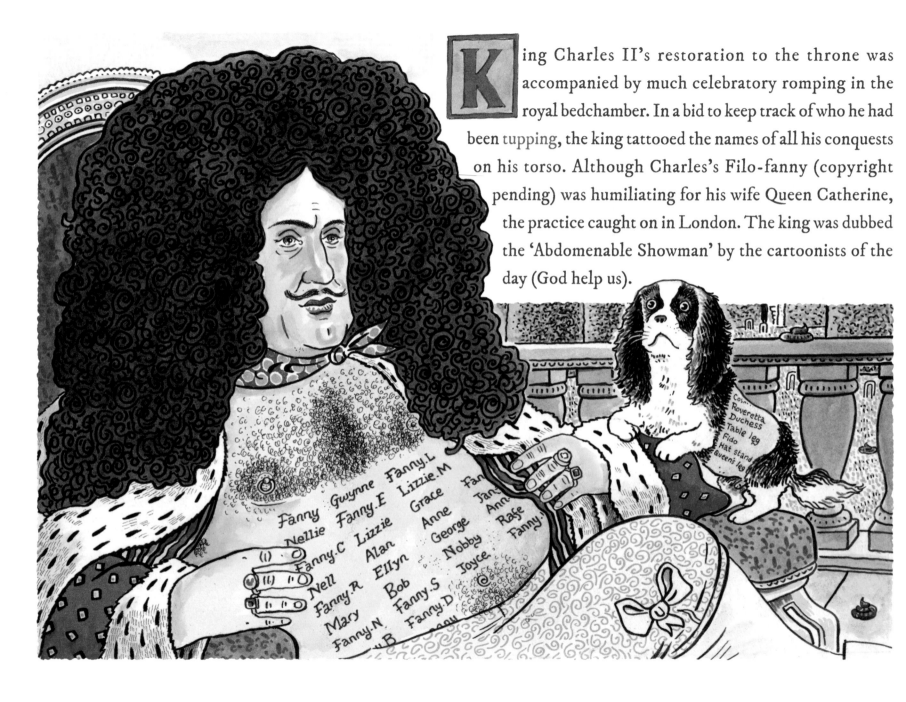

King Charles II's restoration to the throne was accompanied by much celebratory romping in the royal bedchamber. In a bid to keep track of who he had been tupping, the king tattooed the names of all his conquests on his torso. Although Charles's Filo-fanny (copyright pending) was humiliating for his wife Queen Catherine, the practice caught on in London. The king was dubbed the 'Abdomenable Showman' by the cartoonists of the day (God help us).

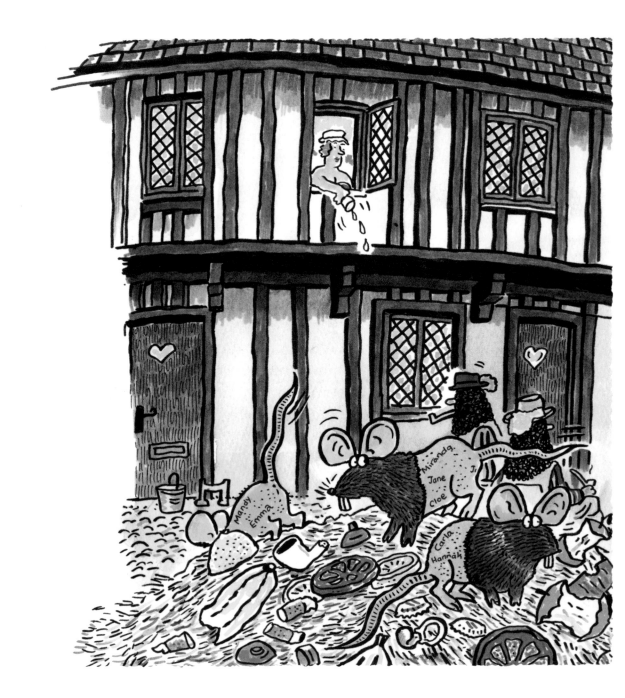

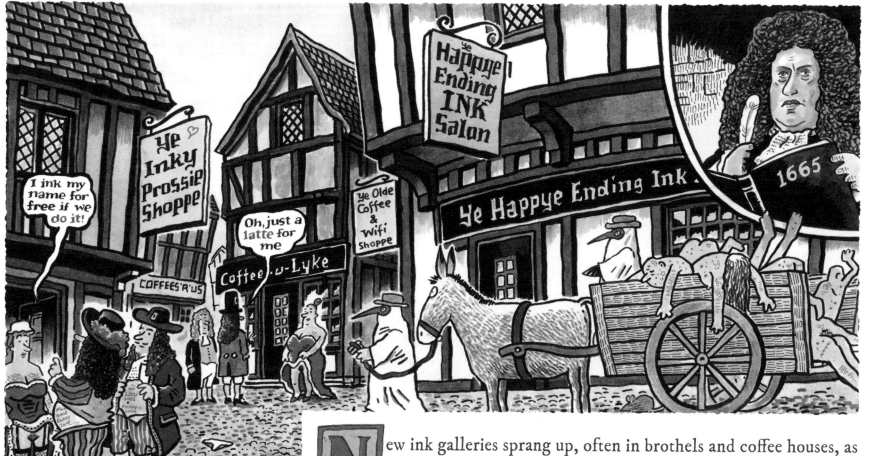

New ink galleries sprang up, often in brothels and coffee houses, as gentlemen flocked to copy King Charles II. The inkers were frequently prostitutes keen to turn their hand to a new skill. They learned to execute the intricate lettering necessary to complete their customers' cunny lists by practising on shaved rats. It was the diarist Samuel Pepys who made the connection between the rapid spread of the Great Plague and London's exquisitely decorated rat population.

In 1691, the explorer William Dampier brought a man to London whose entire body was tattooed. Billed as the Painted Prince or Prince Giolo, he came from the Philippines with Dampier to be exhibited at freak shows and fairs as an oddity.

According to Samuel Pepys' diary, Giolo was introduced to, and enjoyed a threesome with, King William and Queen Mary. Pepys recorded that he himself had been invited to join in but had cried off due to a recurrent bladder infection. Queen Mary became obsessed with Giolo's "symmetrye and his soft blue paws".

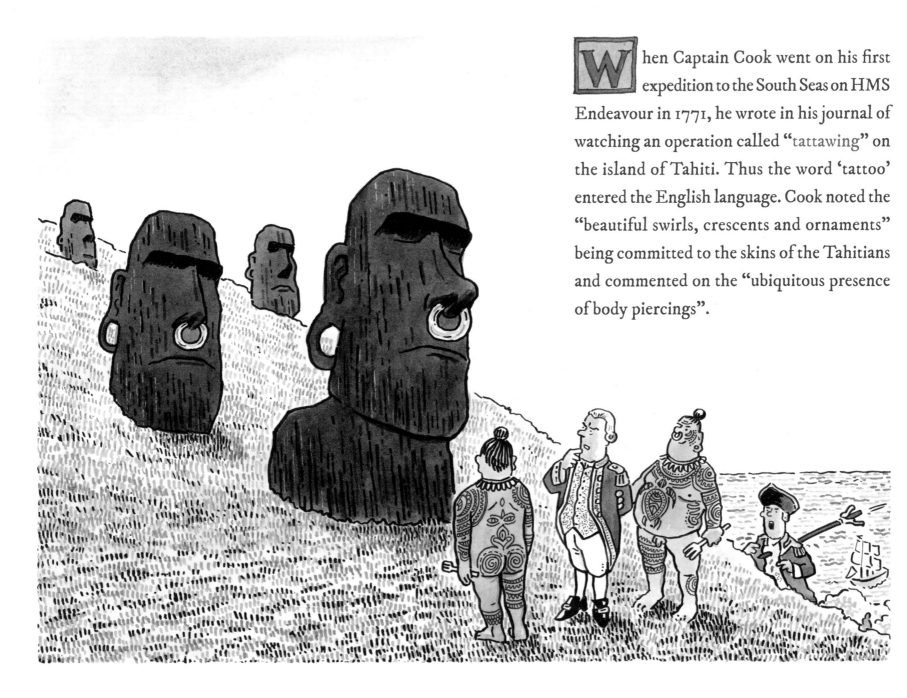

When Captain Cook went on his first expedition to the South Seas on HMS Endeavour in 1771, he wrote in his journal of watching an operation called "tattawing" on the island of Tahiti. Thus the word 'tattoo' entered the English language. Cook noted the "beautiful swirls, crescents and ornaments" being committed to the skins of the Tahitians and commented on the "ubiquitous presence of body piercings".

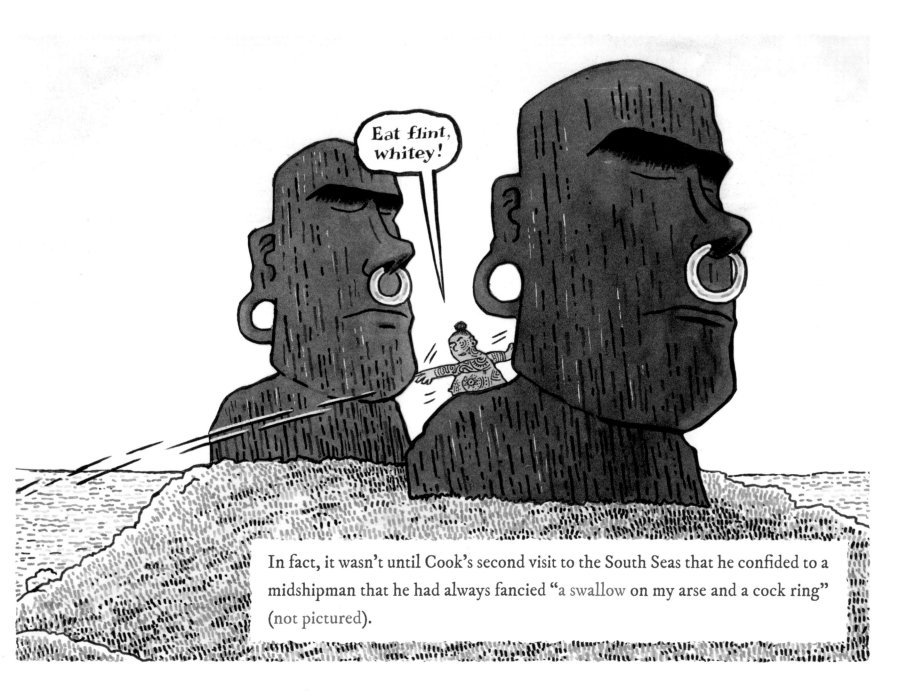

In fact, it wasn't until Cook's second visit to the South Seas that he confided to a midshipman that he had always fancied "a swallow on my arse and a cock ring" (not pictured).

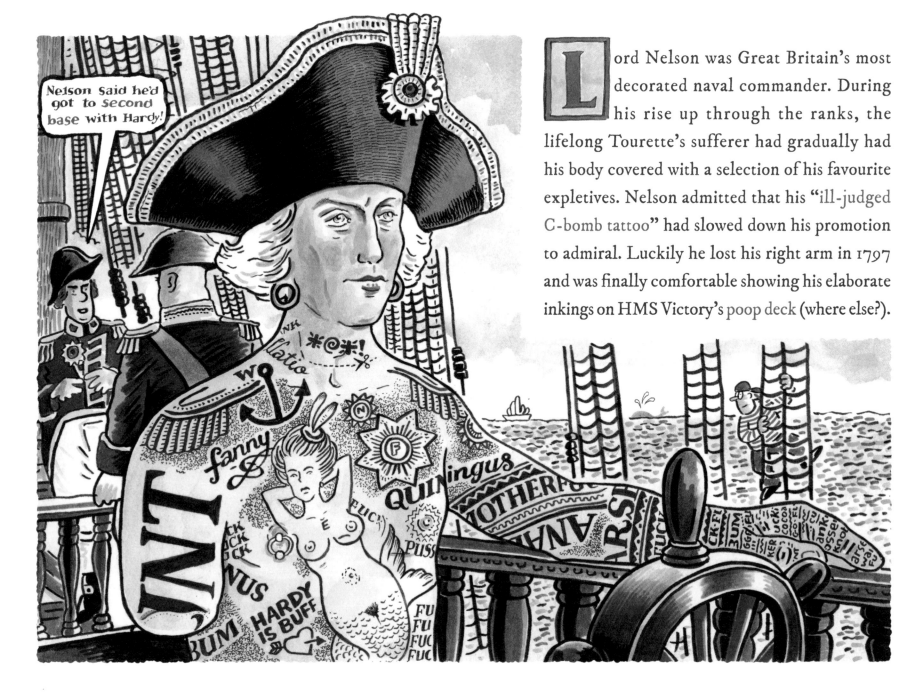

Lord Nelson was Great Britain's most decorated naval commander. During his rise up through the ranks, the lifelong Tourette's sufferer had gradually had his body covered with a selection of his favourite expletives. Nelson admitted that his "ill-judged C-bomb tattoo" had slowed down his promotion to admiral. Luckily he lost his right arm in 1797 and was finally comfortable showing his elaborate inkings on HMS Victory's poop deck (where else?).

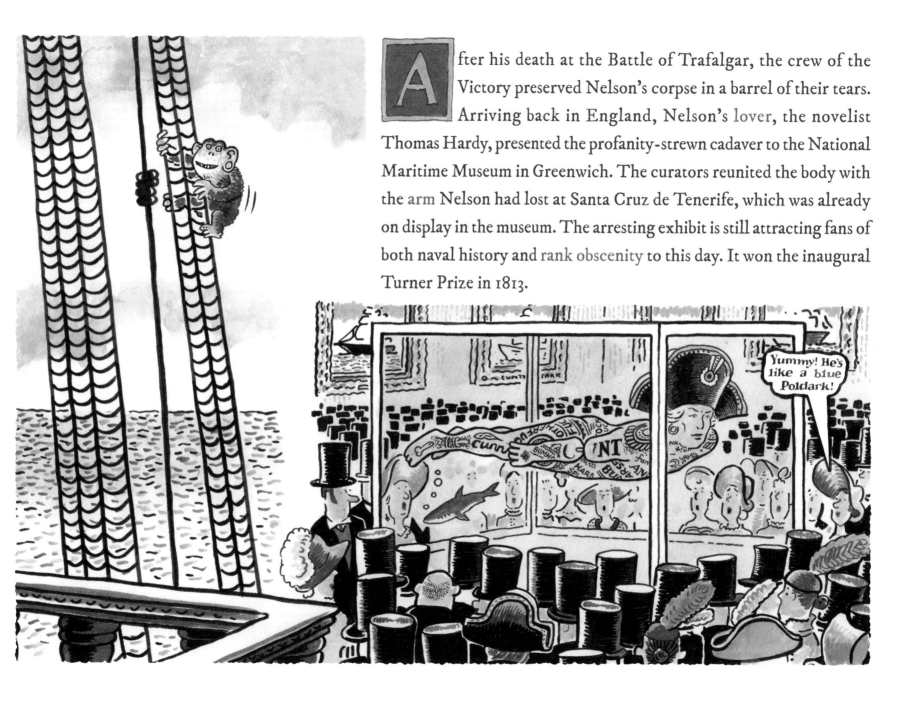

After his death at the Battle of Trafalgar, the crew of the Victory preserved Nelson's corpse in a barrel of their tears. Arriving back in England, Nelson's lover, the novelist Thomas Hardy, presented the profanity-strewn cadaver to the National Maritime Museum in Greenwich. The curators reunited the body with the arm Nelson had lost at Santa Cruz de Tenerife, which was already on display in the museum. The arresting exhibit is still attracting fans of both naval history and rank obscenity to this day. It won the inaugural Turner Prize in 1813.

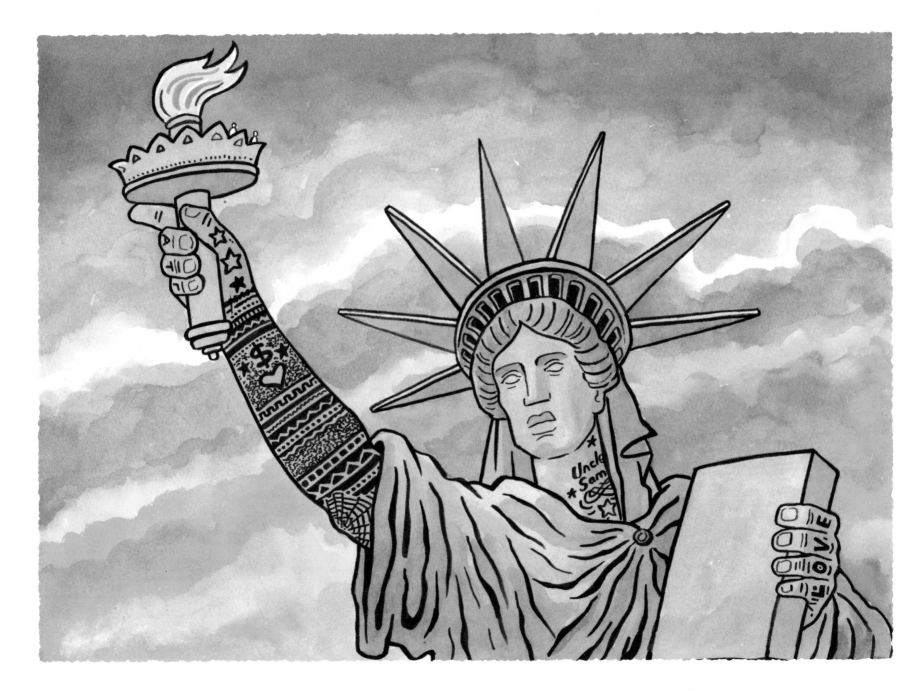

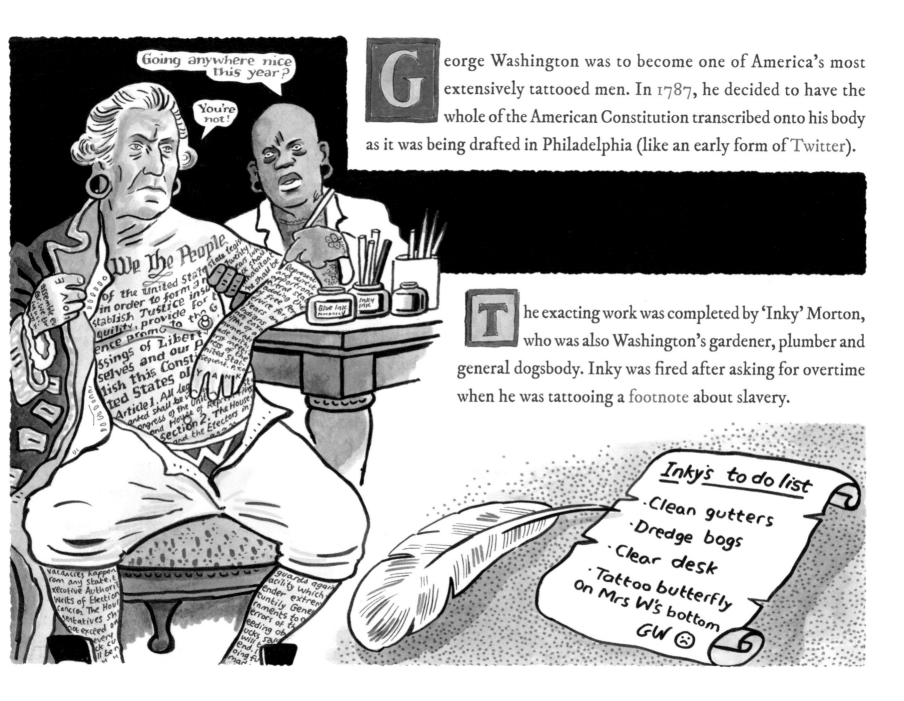

George Washington was to become one of America's most extensively tattooed men. In 1787, he decided to have the whole of the American Constitution transcribed onto his body as it was being drafted in Philadelphia (like an early form of Twitter).

The exacting work was completed by 'Inky' Morton, who was also Washington's gardener, plumber and general dogsbody. Inky was fired after asking for overtime when he was tattooing a footnote about slavery.

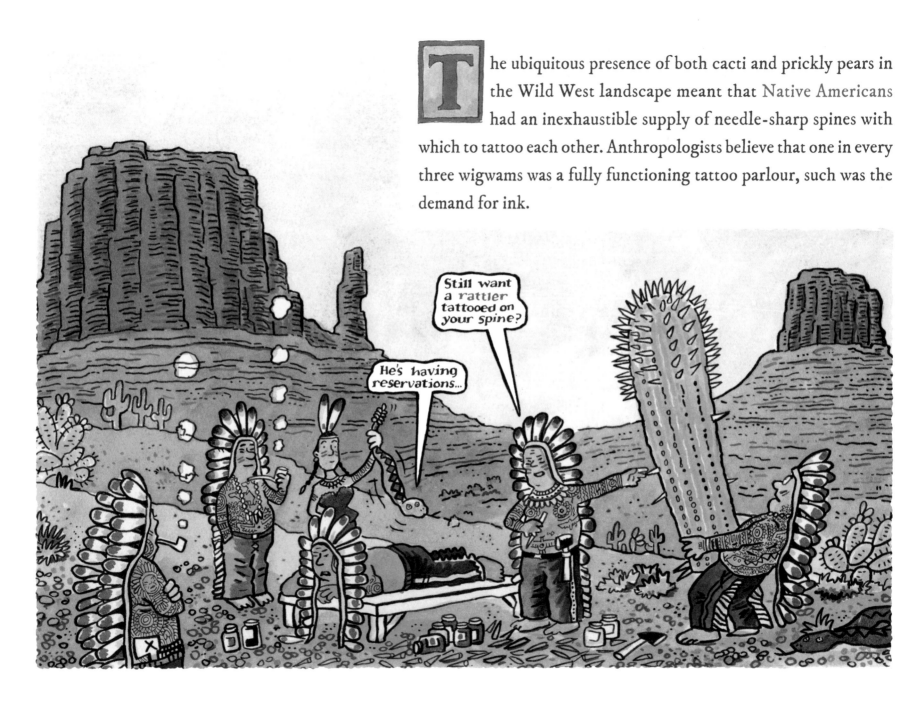

The ubiquitous presence of both cacti and prickly pears in the Wild West landscape meant that Native Americans had an inexhaustible supply of needle-sharp spines with which to tattoo each other. Anthropologists believe that one in every three wigwams was a fully functioning tattoo parlour, such was the demand for ink.

The tattoos were traditionally completed by tribal elders known as skin prickers. The designs were often literal representations of each individual's name. Sitting Bull, for example, had a buffalo reclining in a primitive armchair tattooed on his little big horn (not pictured).

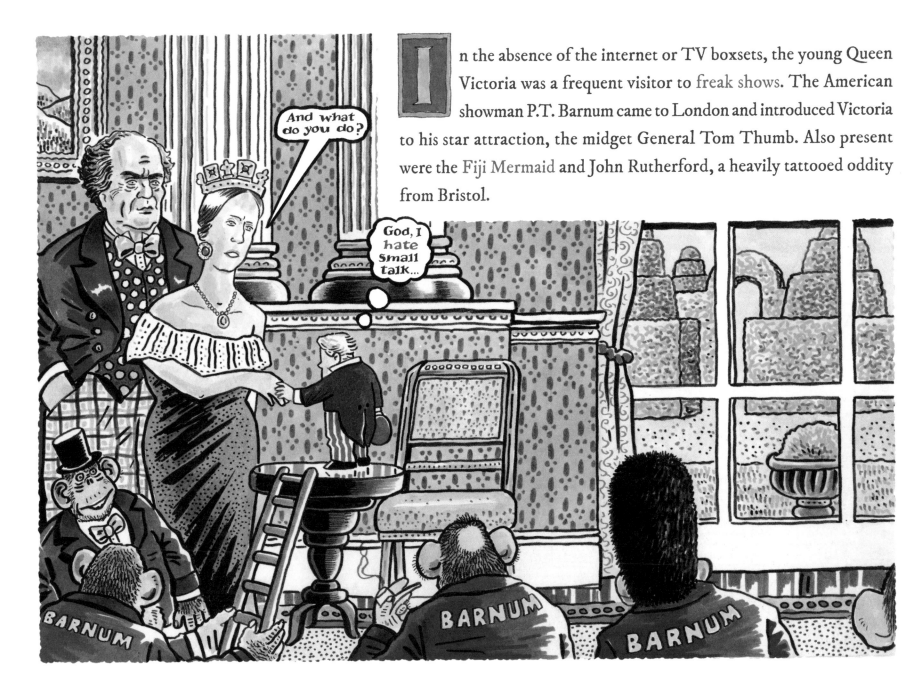

In the absence of the internet or TV boxsets, the young Queen Victoria was a frequent visitor to freak shows. The American showman P.T. Barnum came to London and introduced Victoria to his star attraction, the midget General Tom Thumb. Also present were the Fiji Mermaid and John Rutherford, a heavily tattooed oddity from Bristol.

Rutherford claimed to have been forcibly tattooed from head to toe by a tribe that had taken him prisoner in New Zealand. The tattoos had been executed by fearsome warriors in a terrifying ceremony, according to the indigo sailor. Victoria was captivated by his elaborate designs and confided to her journal that they looked "really edgy and a likkle bit pervy". Her Majesty concluded, "I gots to have one".

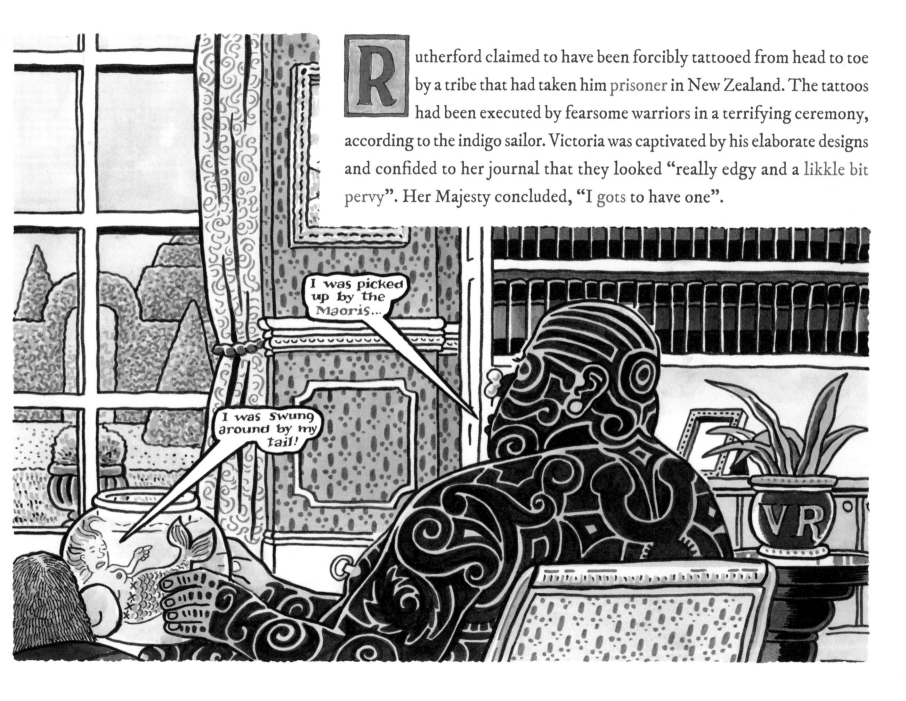

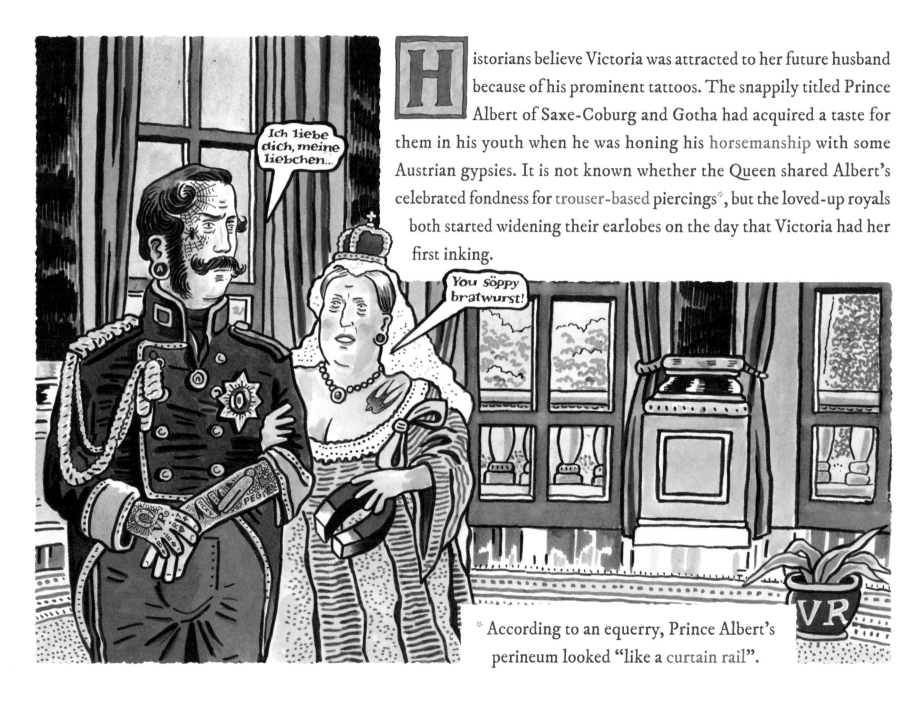

Historians believe Victoria was attracted to her future husband because of his prominent tattoos. The snappily titled Prince Albert of Saxe-Coburg and Gotha had acquired a taste for them in his youth when he was honing his horsemanship with some Austrian gypsies. It is not known whether the Queen shared Albert's celebrated fondness for trouser-based piercings*, but the loved-up royals both started widening their earlobes on the day that Victoria had her first inking.

* According to an equerry, Prince Albert's perineum looked "like a curtain rail".

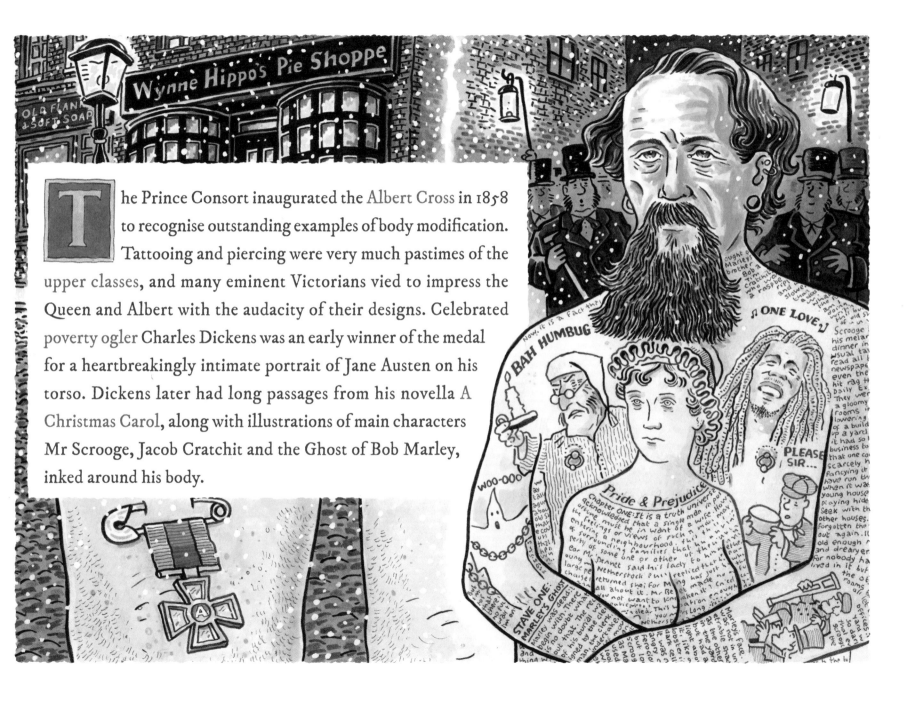

The Prince Consort inaugurated the Albert Cross in 1858 to recognise outstanding examples of body modification. Tattooing and piercing were very much pastimes of the upper classes, and many eminent Victorians vied to impress the Queen and Albert with the audacity of their designs. Celebrated poverty ogler Charles Dickens was an early winner of the medal for a heartbreakingly intimate portrait of Jane Austen on his torso. Dickens later had long passages from his novella A Christmas Carol, along with illustrations of main characters Mr Scrooge, Jacob Cratchit and the Ghost of Bob Marley, inked around his body.

At Prince Albert's suggestion, the Great Exhibition of 1851 was followed a year later by a celebration of the finest British tattoos and body piercings. The week-long event drew large crowds to London's fashionable Hyde Park.

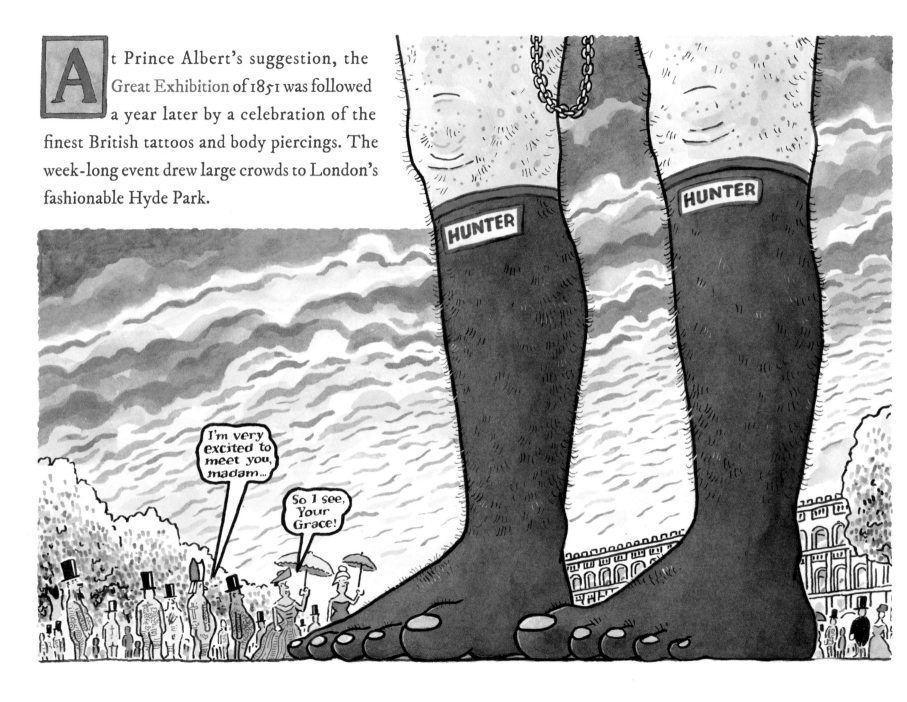

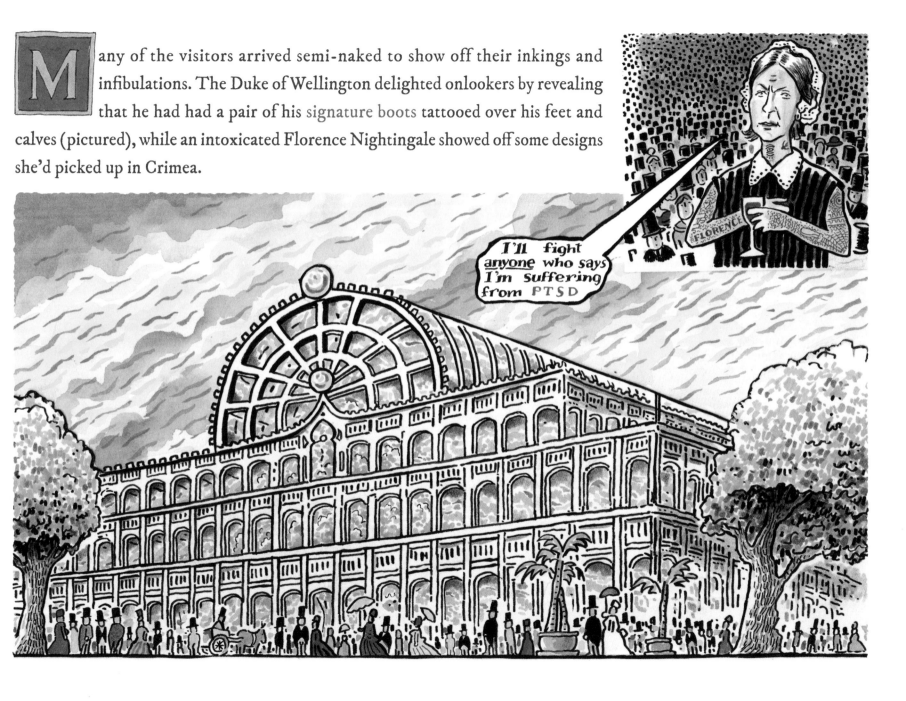

Many of the visitors arrived semi-naked to show off their inkings and infibulations. The Duke of Wellington delighted onlookers by revealing that he had had a pair of his signature boots tattooed over his feet and calves (pictured), while an intoxicated Florence Nightingale showed off some designs she'd picked up in Crimea.

I'll fight anyone who says I'm suffering from PTSD

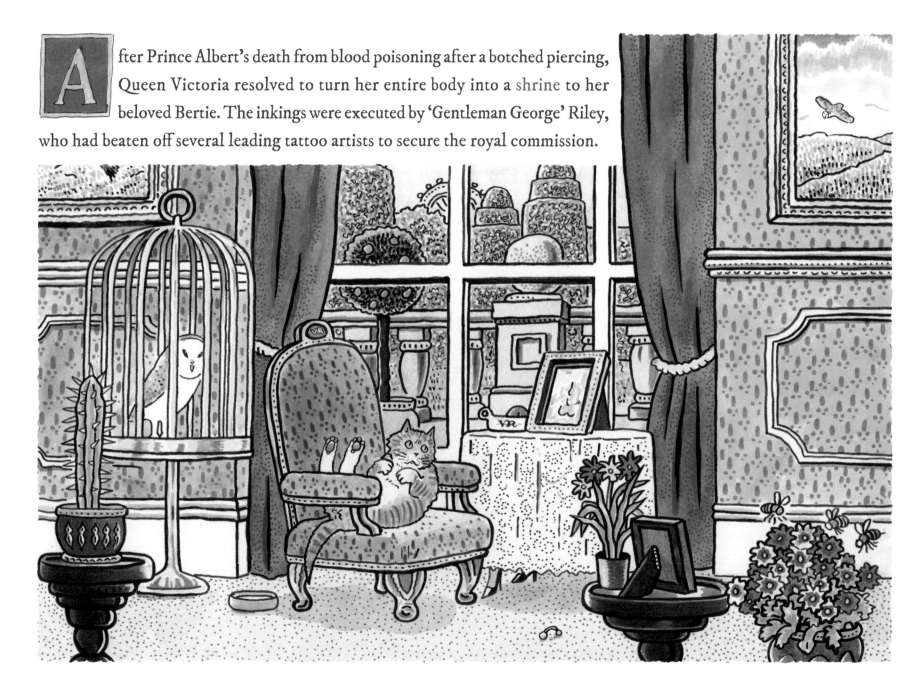

After Prince Albert's death from blood poisoning after a botched piercing, Queen Victoria resolved to turn her entire body into a shrine to her beloved Bertie. The inkings were executed by 'Gentleman George' Riley, who had beaten off several leading tattoo artists to secure the royal commission.

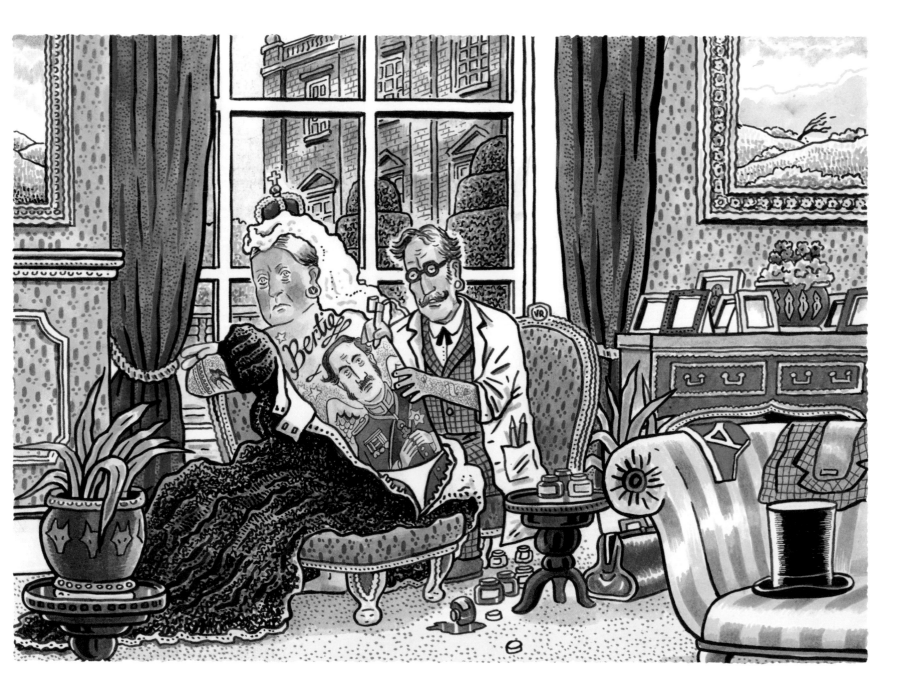

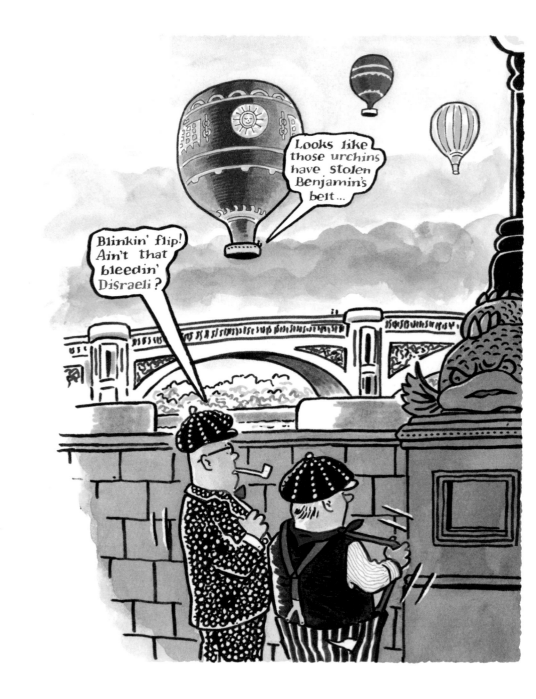

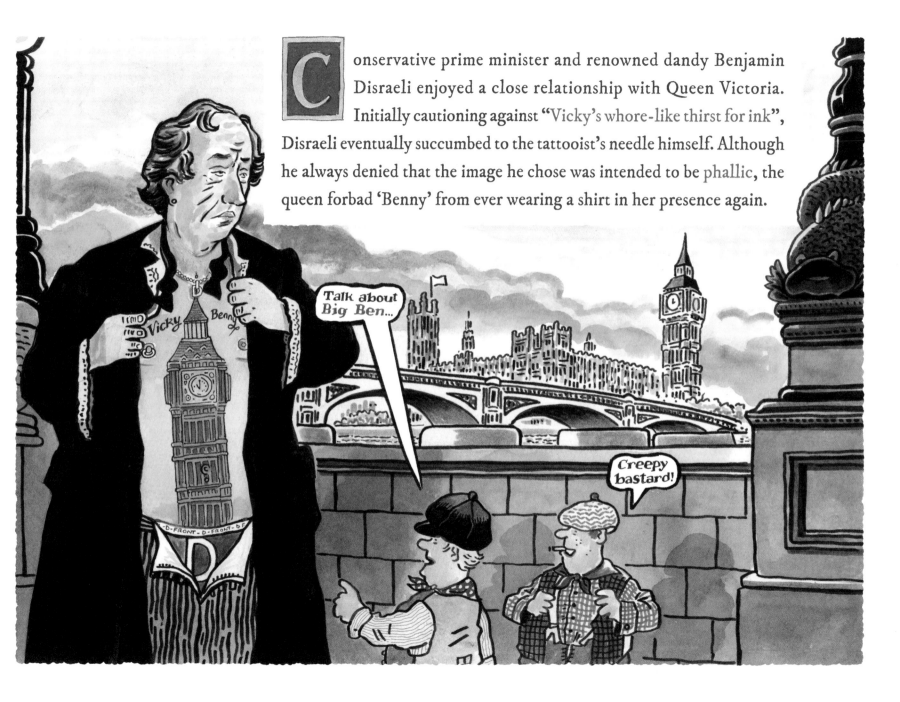

Conservative prime minister and renowned dandy Benjamin Disraeli enjoyed a close relationship with Queen Victoria. Initially cautioning against "Vicky's whore-like thirst for ink", Disraeli eventually succumbed to the tattooist's needle himself. Although he always denied that the image he chose was intended to be phallic, the queen forbad 'Benny' from ever wearing a shirt in her presence again.

The naturalist Charles Darwin was never seen in public without his top hat. This was due to the traditional Ecuadorian tattoo that decorated his dome. Darwin had acquired the inking when birdwatching on acid in the Galapagos islands.

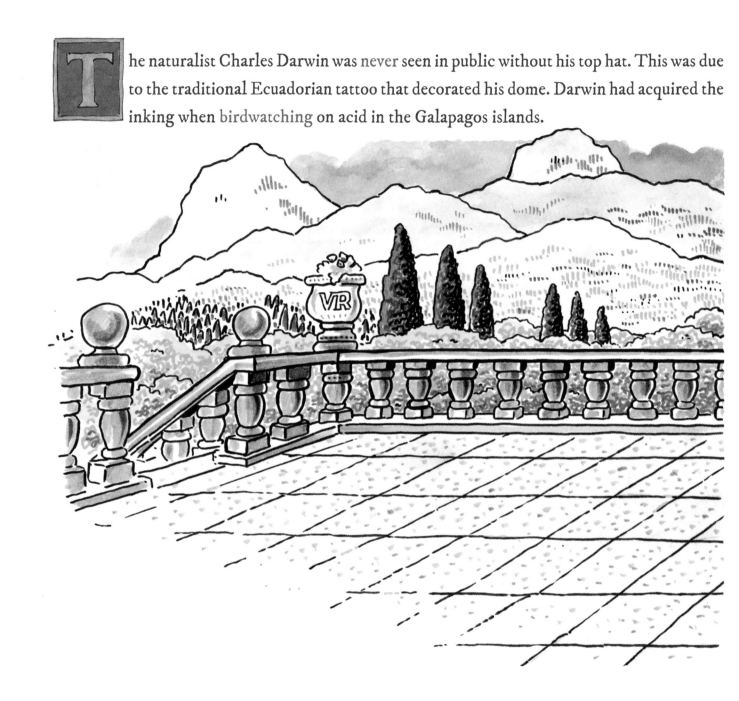

arwin was finally forced to remove his topper when he was invited to explain his theory of evolution to Queen Victoria at Balmoral. Although the queen was impressed by the tattoo, her on/off lover John 'Murky' Brown said the tortoise represented "two fingers to the British Empire and was an affront to civilised society".

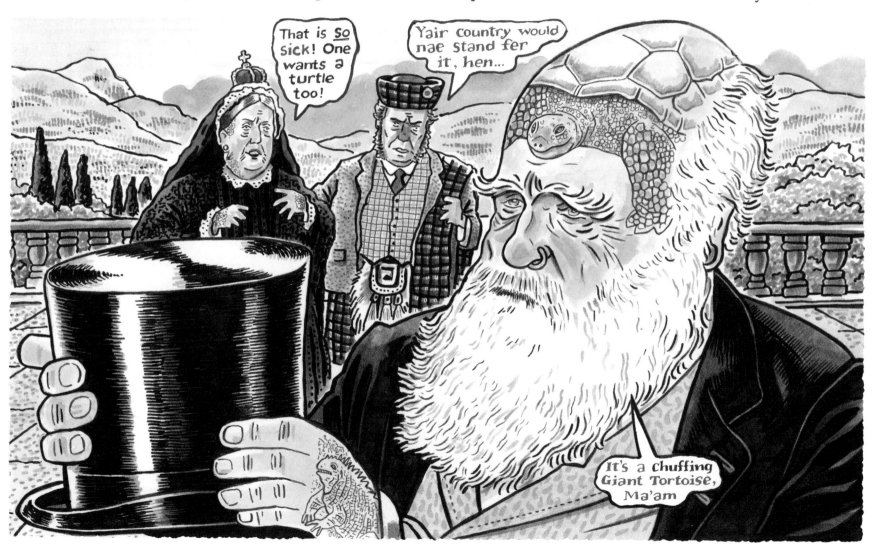

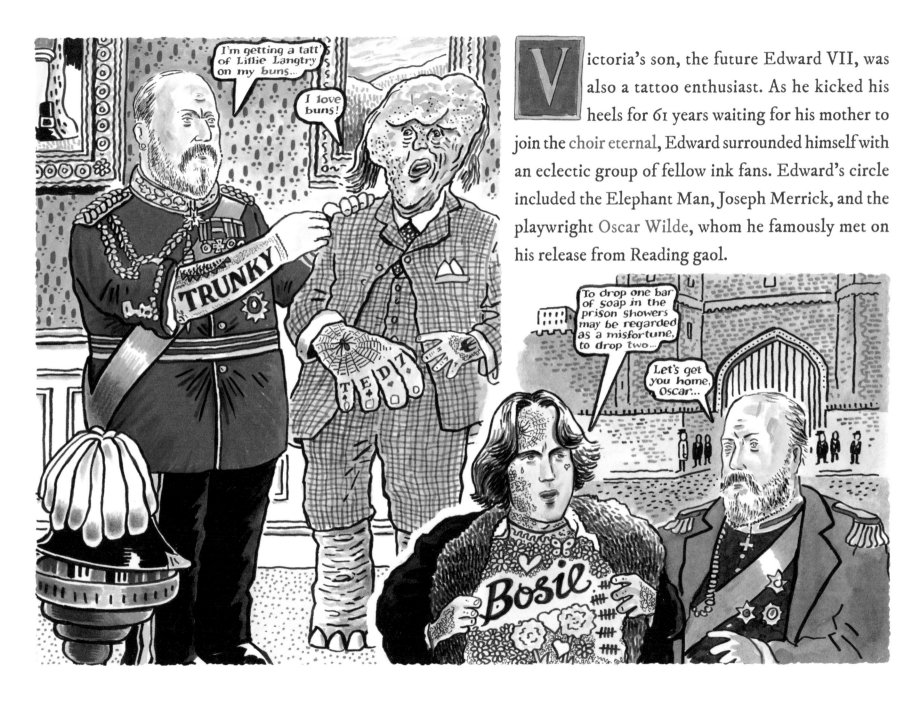

Victoria's son, the future Edward VII, was also a tattoo enthusiast. As he kicked his heels for 61 years waiting for his mother to join the choir eternal, Edward surrounded himself with an eclectic group of fellow ink fans. Edward's circle included the Elephant Man, Joseph Merrick, and the playwright Oscar Wilde, whom he famously met on his release from Reading gaol.

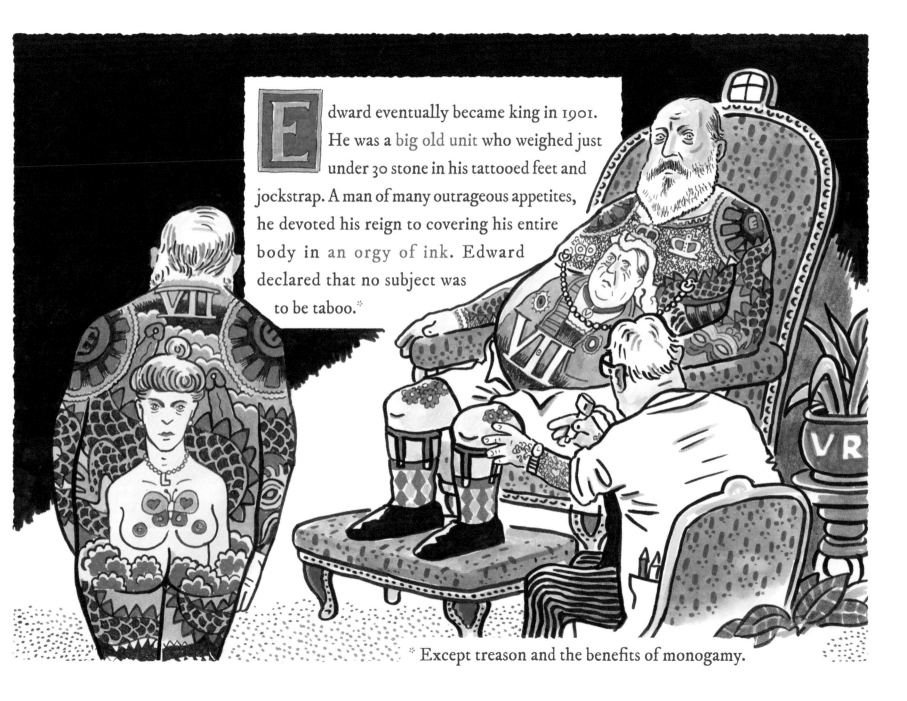

Edward eventually became king in 1901. He was a big old unit who weighed just under 30 stone in his tattooed feet and jockstrap. A man of many outrageous appetites, he devoted his reign to covering his entire body in an orgy of ink. Edward declared that no subject was to be taboo.*

* Except treason and the benefits of monogamy.

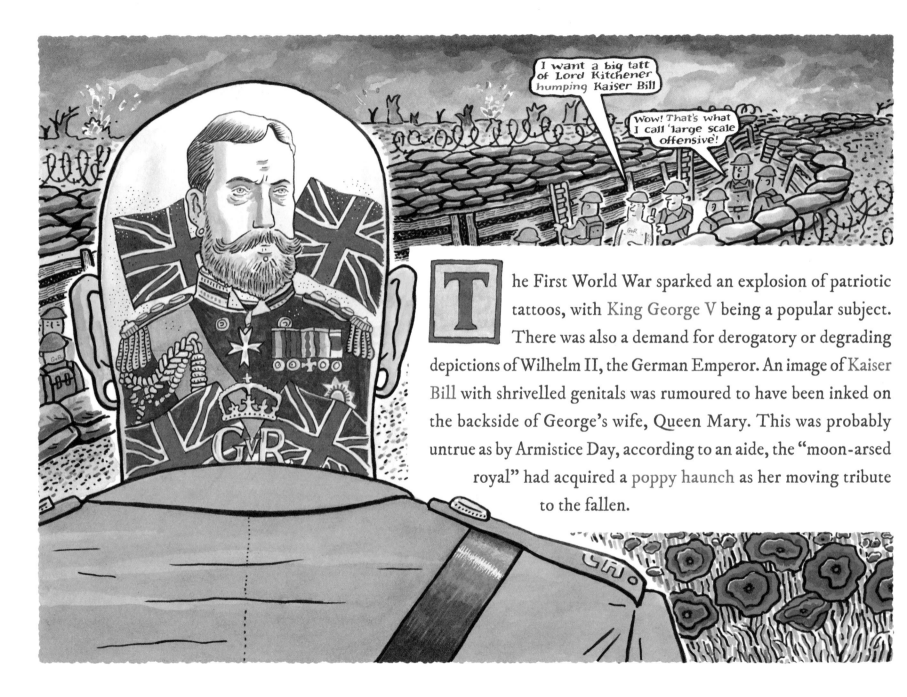

The First World War sparked an explosion of patriotic tattoos, with King George V being a popular subject. There was also a demand for derogatory or degrading depictions of Wilhelm II, the German Emperor. An image of Kaiser Bill with shrivelled genitals was rumoured to have been inked on the backside of George's wife, Queen Mary. This was probably untrue as by Armistice Day, according to an aide, the "moon-arsed royal" had acquired a poppy haunch as her moving tribute to the fallen.

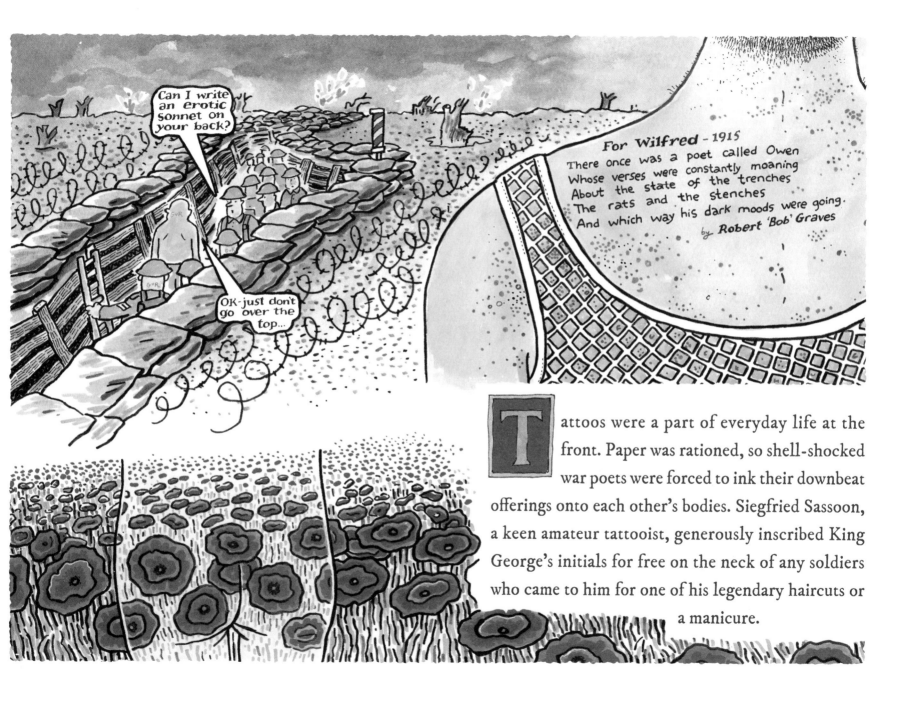

For Wilfred - 1915
There once was a poet called Owen
Whose verses were constantly moaning
About the state of the trenches
The rats and the stenches
And which way his dark moods were going.
by Robert 'Bob' Graves

Tattoos were a part of everyday life at the front. Paper was rationed, so shell-shocked war poets were forced to ink their downbeat offerings onto each other's bodies. Siegfried Sassoon, a keen amateur tattooist, generously inscribed King George's initials for free on the neck of any soldiers who came to him for one of his legendary haircuts or a manicure.

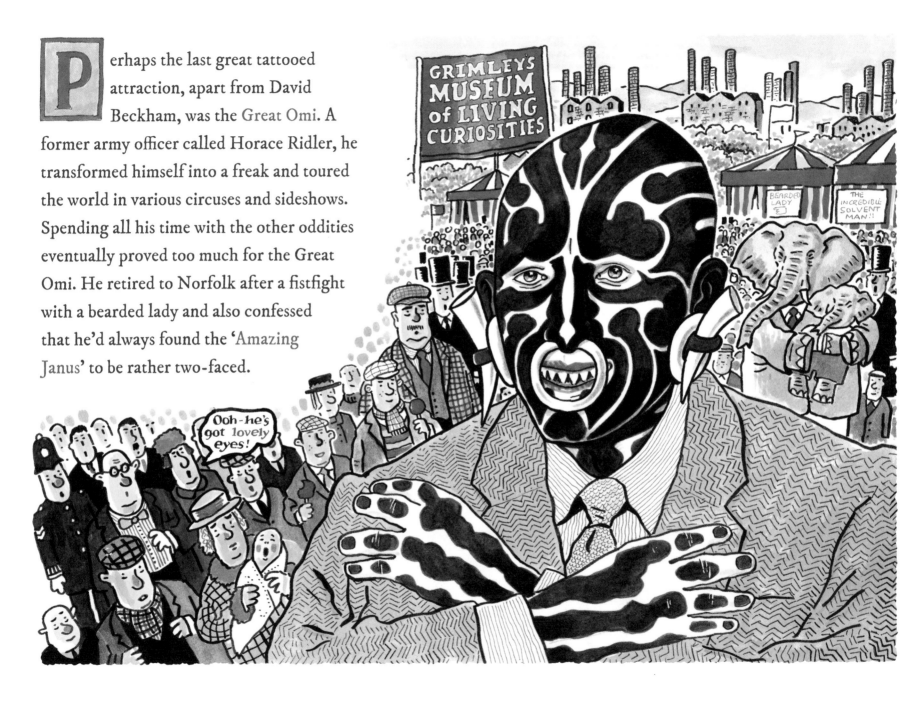

Perhaps the last great tattooed attraction, apart from David Beckham, was the Great Omi. A former army officer called Horace Ridler, he transformed himself into a freak and toured the world in various circuses and sideshows. Spending all his time with the other oddities eventually proved too much for the Great Omi. He retired to Norfolk after a fistfight with a bearded lady and also confessed that he'd always found the 'Amazing Janus' to be rather two-faced.

GRIMLEYS MUSEUM of LIVING CURIOSITIES

BEARDED LADY

THE INCREDIBLE SOLVENT MAN !!

Ooh - he's got lovely eyes!

The Great Omi's extensive tattoos were completed in London, but many tattoo aficionados would travel to studios in Japan to have ambitious designs executed. The Japanese horis were considered to be the finest tattoo artists in the world. In recent times, a cynical product placement scandal has sullied their good reputation. An extensive investigation resulted in several horis and their geishas being fingered by Tokyo police.

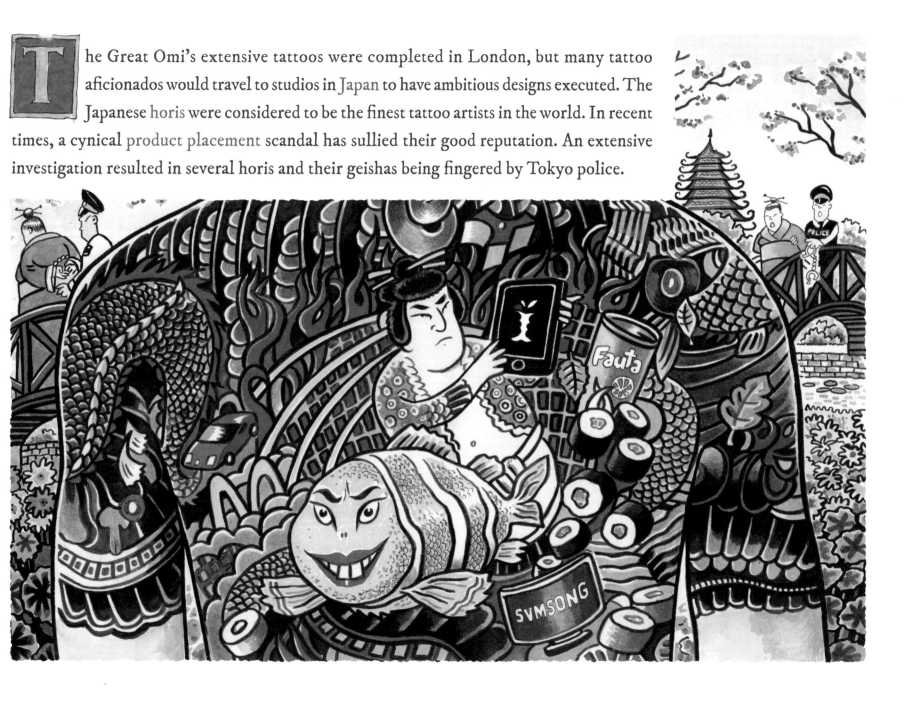

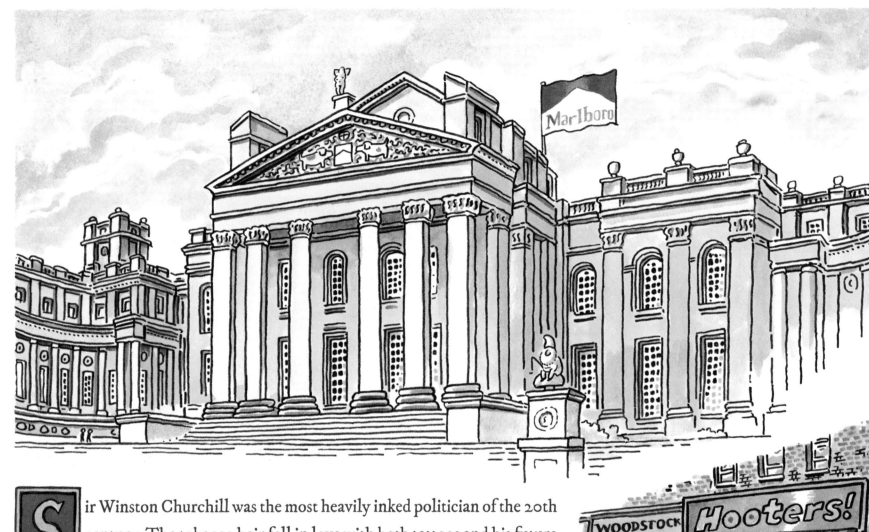

Sir Winston Churchill was the most heavily inked politician of the 20th century. The tobacco heir fell in love with both tattoos and his future wife Clementine at a topless bar near Blenheim Palace where she waitressed. A besotted Winston recalled, "One's eye was drawn to the butterfly on her tit, but she had many more below her plimsoll line."

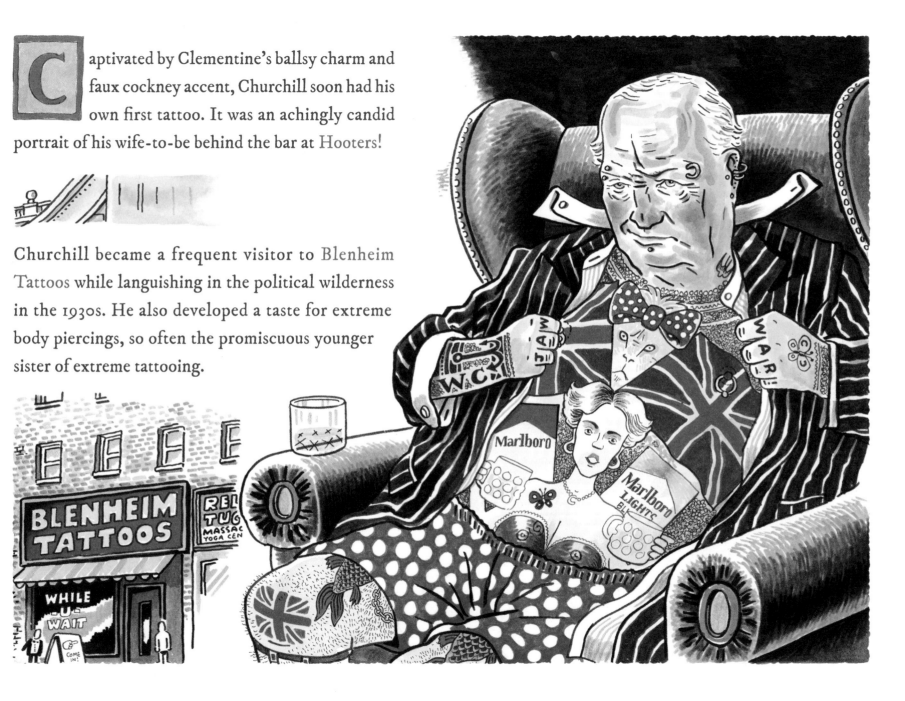

Captivated by Clementine's ballsy charm and faux cockney accent, Churchill soon had his own first tattoo. It was an achingly candid portrait of his wife-to-be behind the bar at Hooters!

Churchill became a frequent visitor to Blenheim Tattoos while languishing in the political wilderness in the 1930s. He also developed a taste for extreme body piercings, so often the promiscuous younger sister of extreme tattooing.

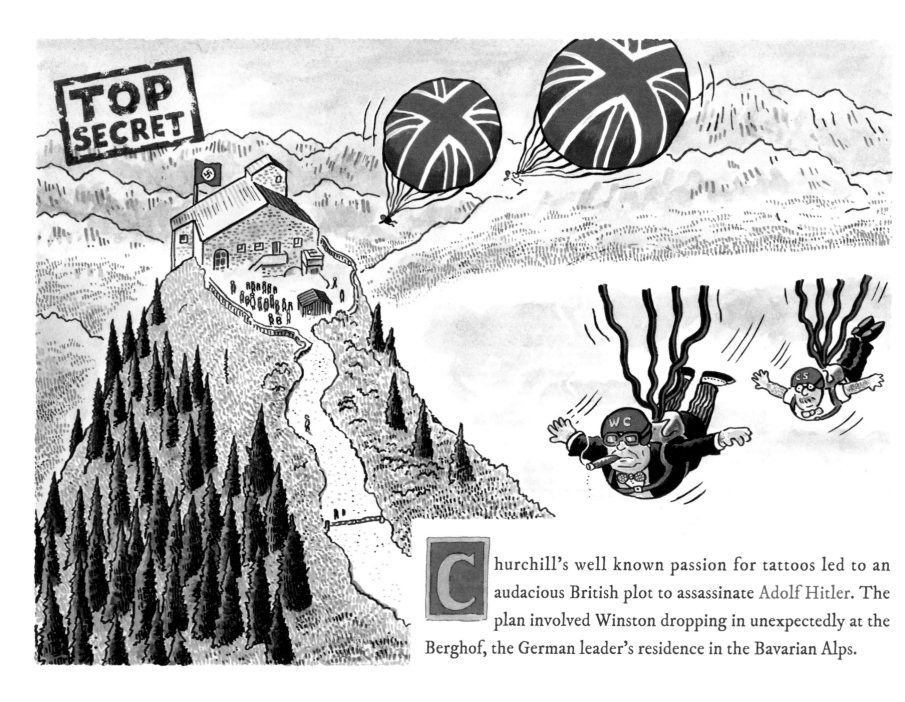

TOP SECRET

C hurchill's well known passion for tattoos led to an audacious British plot to assassinate Adolf Hitler. The plan involved Winston dropping in unexpectedly at the Berghof, the German leader's residence in the Bavarian Alps.

DITTO

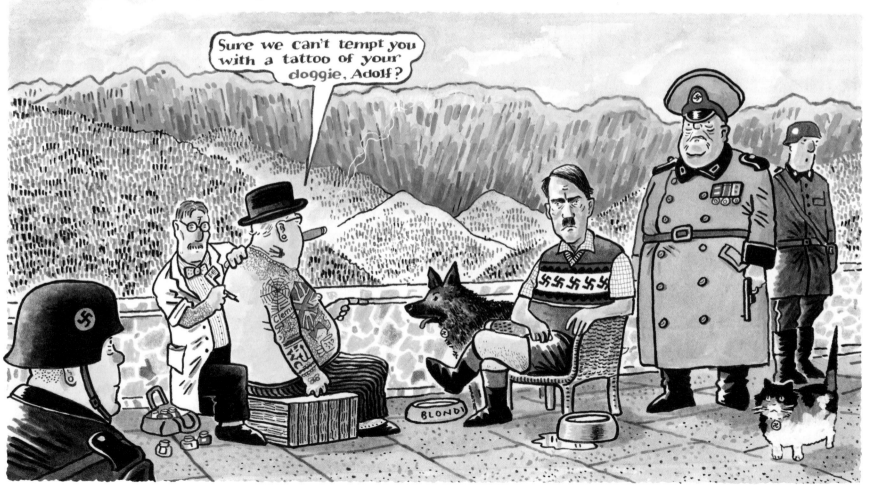

Churchill was accompanied to the informal 'meet and greet' by Claude Slippers, an Oxford-based inker. The Führer was to be poisoned by Slippers with a tattoo gun filled with strychnine as he and Churchill attempted to thrash out a last-ditch peace treaty. Sadly, Hitler was even less keen on tattoos than he was on meat eaters, smokers and poor table manners.

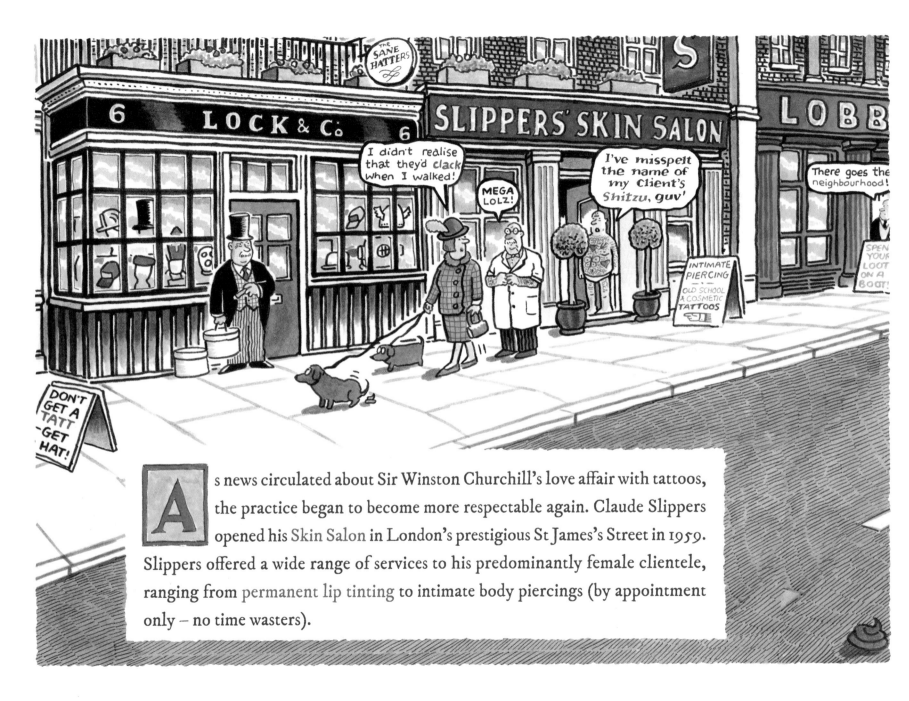

As news circulated about Sir Winston Churchill's love affair with tattoos, the practice began to become more respectable again. Claude Slippers opened his Skin Salon in London's prestigious St James's Street in 1959. Slippers offered a wide range of services to his predominantly female clientele, ranging from permanent lip tinting to intimate body piercings (by appointment only – no time wasters).

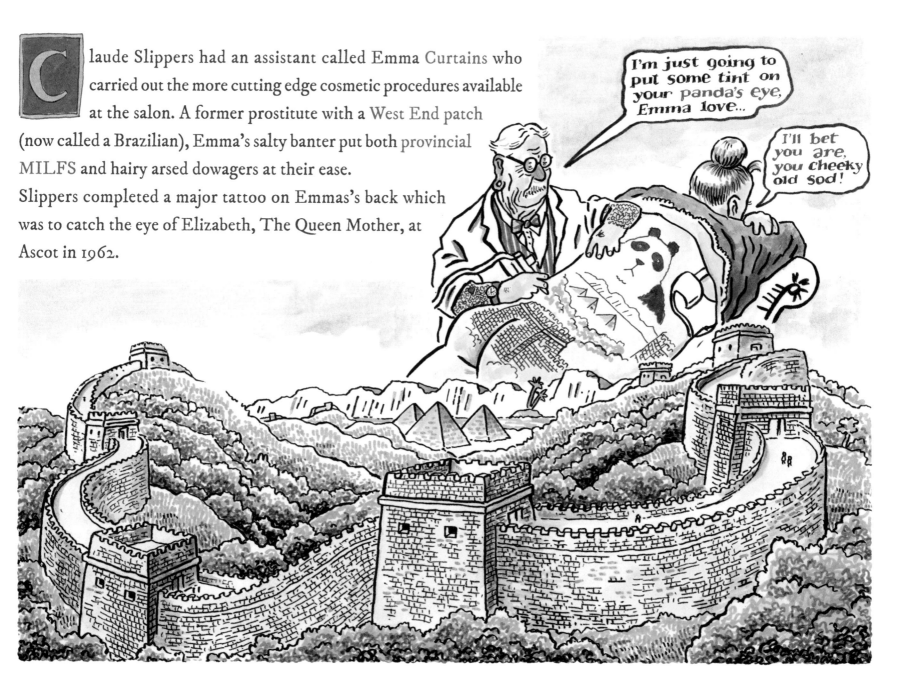

Claude Slippers had an assistant called Emma Curtains who carried out the more cutting edge cosmetic procedures available at the salon. A former prostitute with a West End patch (now called a Brazilian), Emma's salty banter put both provincial MILFS and hairy arsed dowagers at their ease.

Slippers completed a major tattoo on Emmas's back which was to catch the eye of Elizabeth, The Queen Mother, at Ascot in 1962.

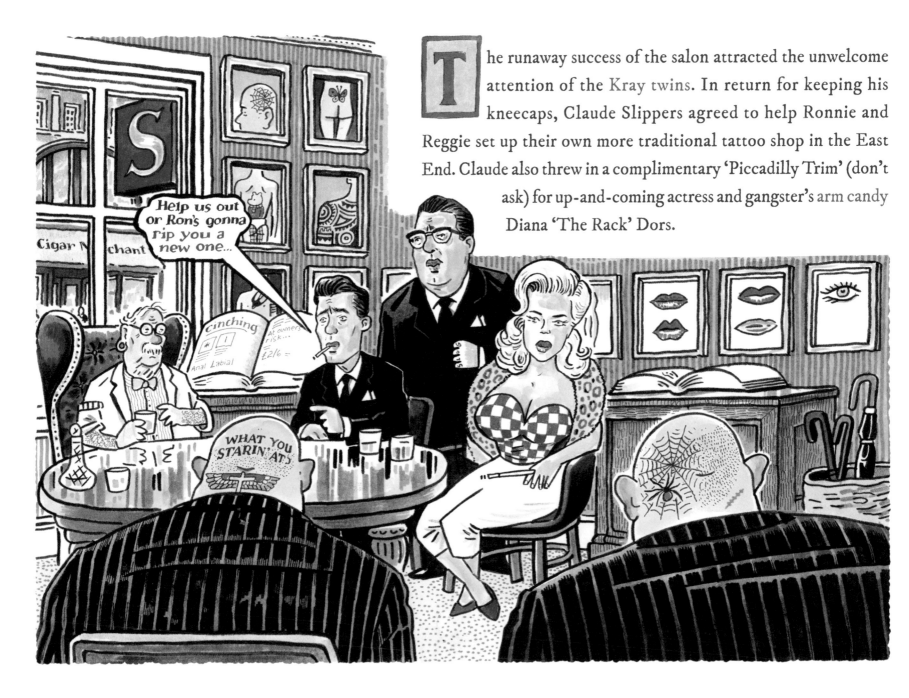

The runaway success of the salon attracted the unwelcome attention of the Kray twins. In return for keeping his kneecaps, Claude Slippers agreed to help Ronnie and Reggie set up their own more traditional tattoo shop in the East End. Claude also threw in a complimentary 'Piccadilly Trim' (don't ask) for up-and-coming actress and gangster's arm candy Diana 'The Rack' Dors.

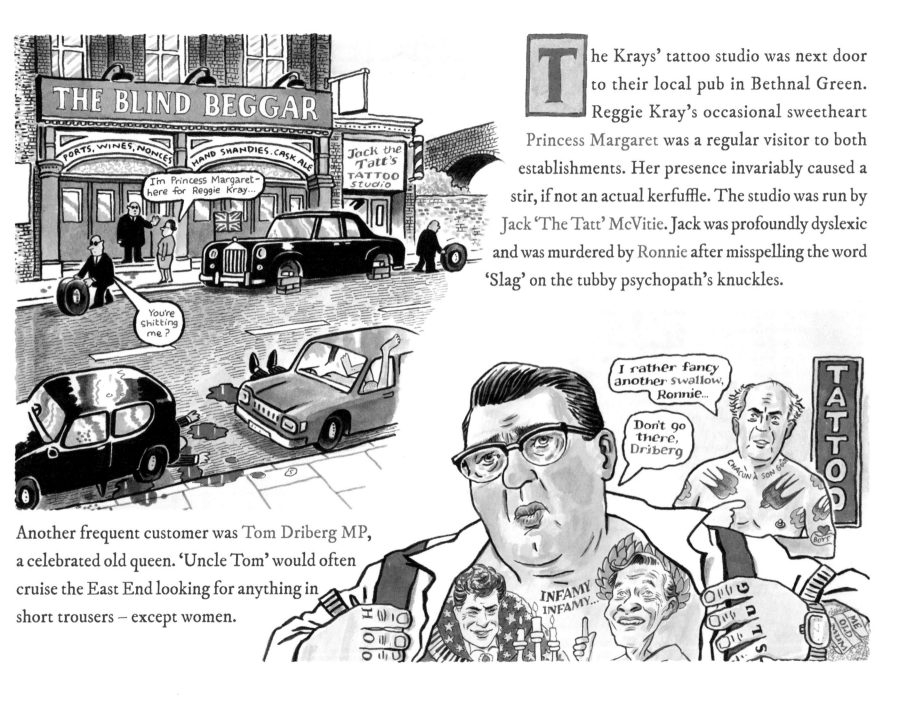

The Krays' tattoo studio was next door to their local pub in Bethnal Green. Reggie Kray's occasional sweetheart Princess Margaret was a regular visitor to both establishments. Her presence invariably caused a stir, if not an actual kerfuffle. The studio was run by Jack 'The Tatt' McVitie. Jack was profoundly dyslexic and was murdered by Ronnie after misspelling the word 'Slag' on the tubby psychopath's knuckles.

Another frequent customer was Tom Driberg MP, a celebrated old queen. 'Uncle Tom' would often cruise the East End looking for anything in short trousers – except women.

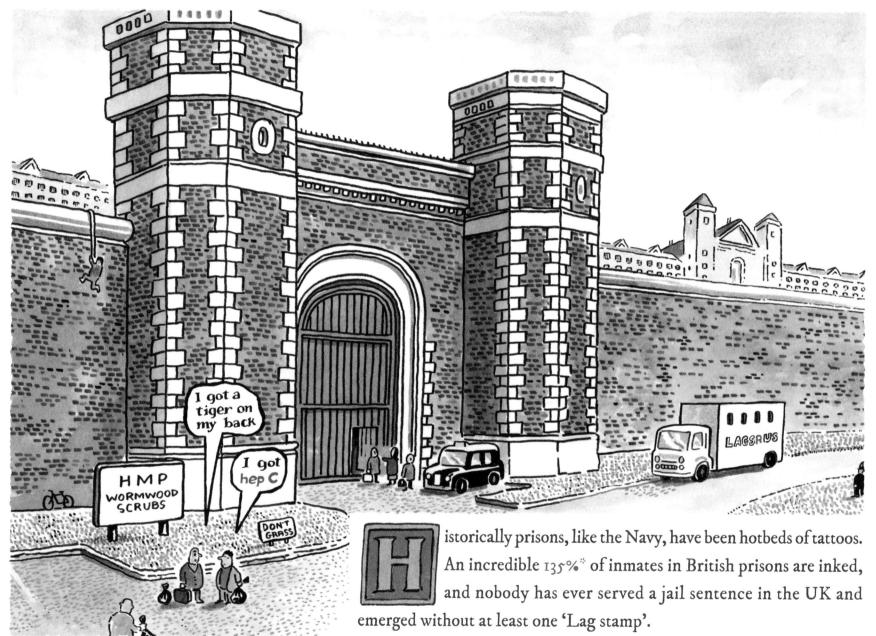

istorically prisons, like the Navy, have been hotbeds of tattoos. An incredible 135%* of inmates in British prisons are inked, and nobody has ever served a jail sentence in the UK and emerged without at least one 'Lag stamp'.

Wormwood Scrubs prison was "balls deep in nonces and shitty tattooists", according to the KGB spy George Blake. So appalled was Blake by the poor quality of the design he received from 'Teapot' Taylor, he escaped over the wall to Moscow in 1966.

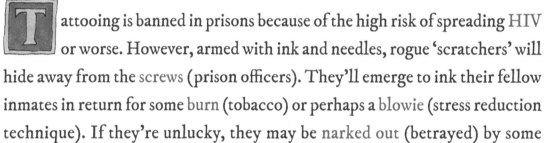

Tattooing is banned in prisons because of the high risk of spreading HIV or worse. However, armed with ink and needles, rogue 'scratchers' will hide away from the screws (prison officers). They'll emerge to ink their fellow inmates in return for some burn (tobacco) or perhaps a blowie (stress reduction technique). If they're unlucky, they may be narked out (betrayed) by some goody goody arsehole (usually a disgraced MP) and sent to see the governor to be disciplined.

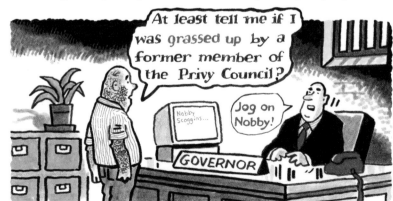

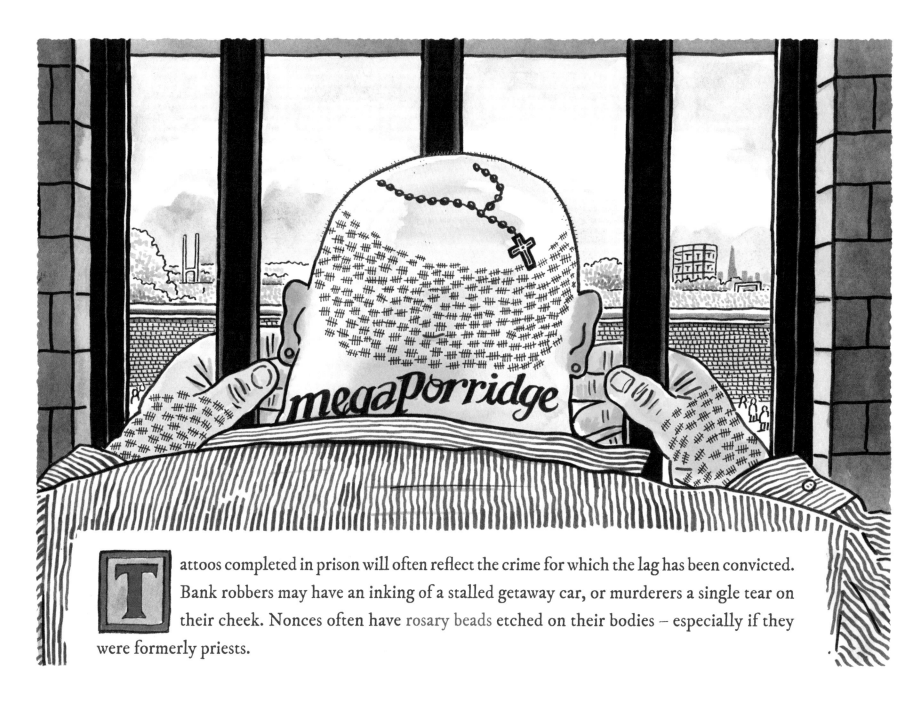

attoos completed in prison will often reflect the crime for which the lag has been convicted. Bank robbers may have an inking of a stalled getaway car, or murderers a single tear on their cheek. Nonces often have rosary beads etched on their bodies – especially if they were formerly priests.

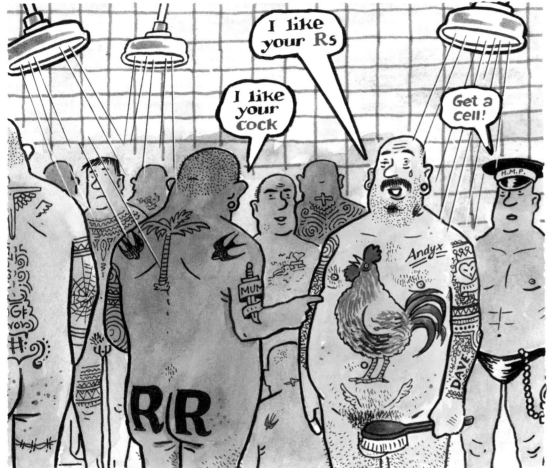

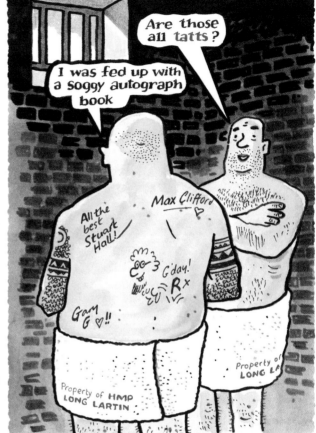

As well as being a great place to see light entertainers from the 1970s naked, the showers are the hub of every prison's tattoo culture. Inmates promenade like peacocks, showing off their tatts to their peers. Bold or original designs will be acknowledged by a tap on the bottom (pictured), invariably followed by a vigorous embrace.

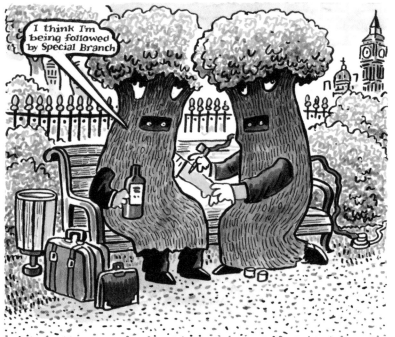

During the Cold War, the Soviet Union perfected a technique for tattooing their spies with a virtually undetectable pigment. Any agents who believed they had been exposed would be invisibly inked by their KGB controller with the most valuable intelligence before they fled to the USSR. Guy Burgess so enjoyed the sensation of being tattooed that he often told his Kremlin bosses that he'd been blown in the hope of receiving some commie ink.

The return of gulag chic to the Moscow catwalks has prompted Russia's macho President Vladimir Putin to reveal a torso that is covered in tattoos. The botox-loving democracyphobe had until recently hidden his elaborate gang-style inkings beneath a bespoke plutonium-based concealer.

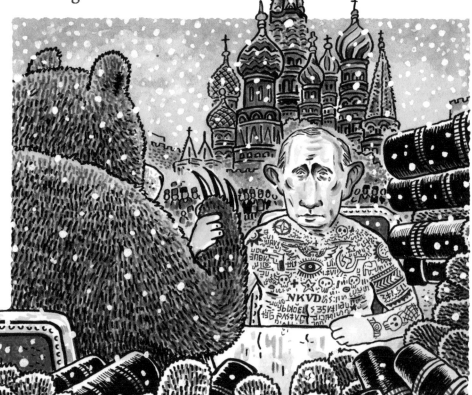

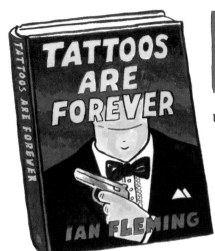

Ian Fleming's James Bond novels were a heady cocktail of espionage, casual sex and tattoos. During his time in the Royal Navy, Fleming had been shocked by the ubiquity of inkings among the lower ranks.

Born and raised in Downton Abbey, and also a phenomenal snob, Fleming believed that the only suitable subject for a tattoo was one's family motto – preferably in Latin.* The Bond books, particularly 'Dr Just Say No', were Fleming's attempt to ridicule the increasing popularity of tattoos in the hope that they would remain the preserve of the aristocracy.

* BONDUS·ODDTOBUS·BOWLER'AT

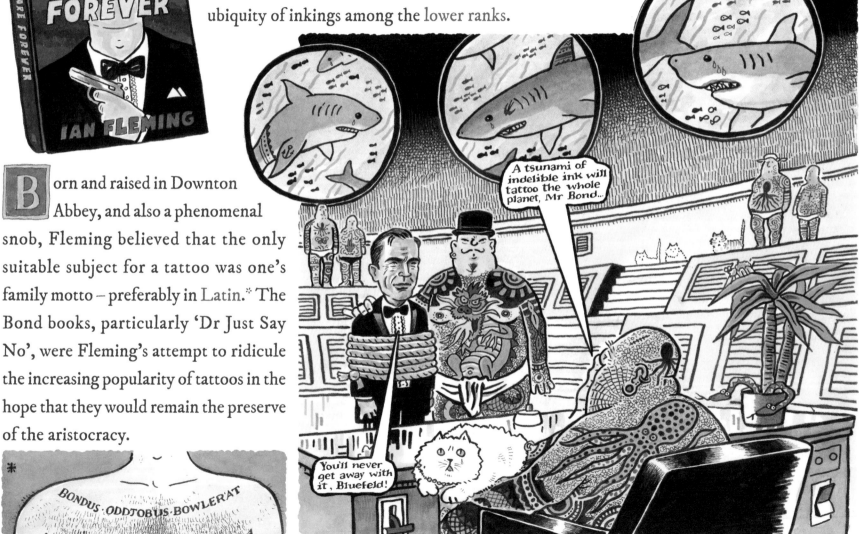

A tsunami of indelible ink will tattoo the whole planet, Mr Bond...

You'll never get away with it, Bluefeld!

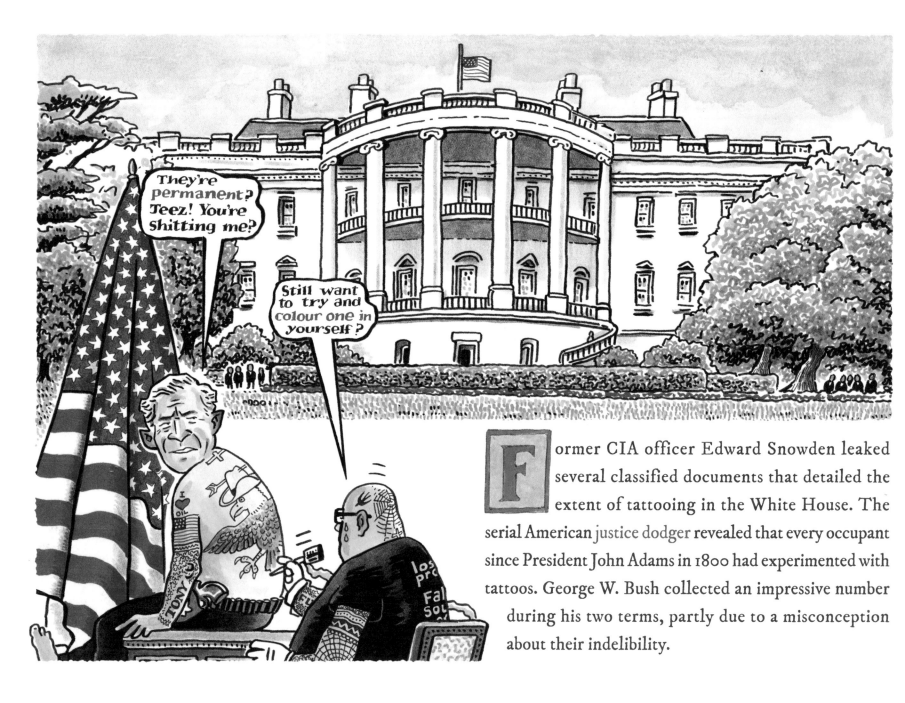

ormer CIA officer Edward Snowden leaked several classified documents that detailed the extent of tattooing in the White House. The serial American justice dodger revealed that every occupant since President John Adams in 1800 had experimented with tattoos. George W. Bush collected an impressive number during his two terms, partly due to a misconception about their indelibility.

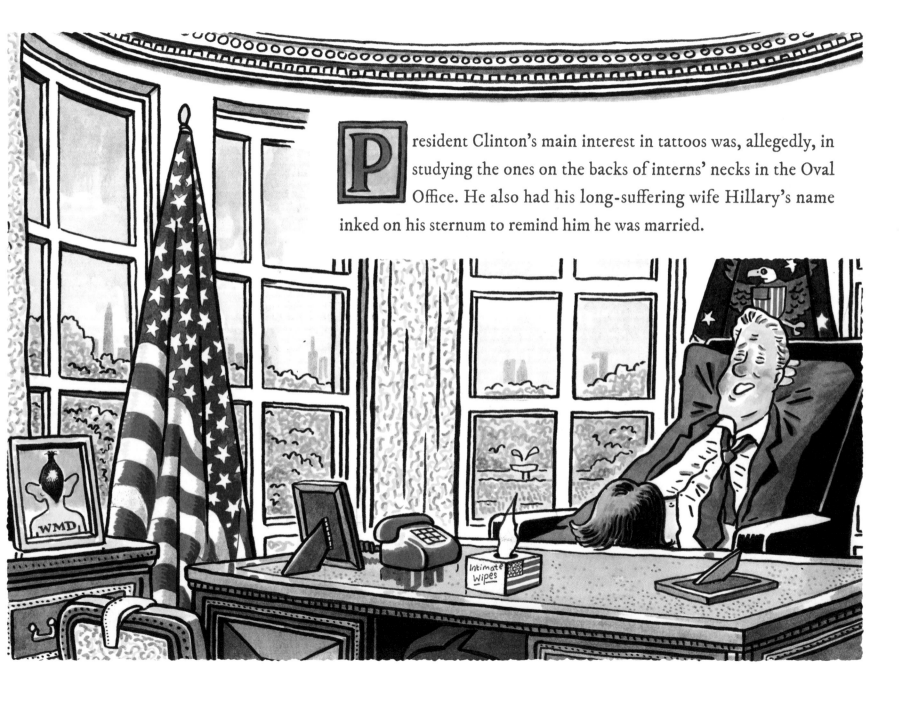

President Clinton's main interest in tattoos was, allegedly, in studying the ones on the backs of interns' necks in the Oval Office. He also had his long-suffering wife Hillary's name inked on his sternum to remind him he was married.

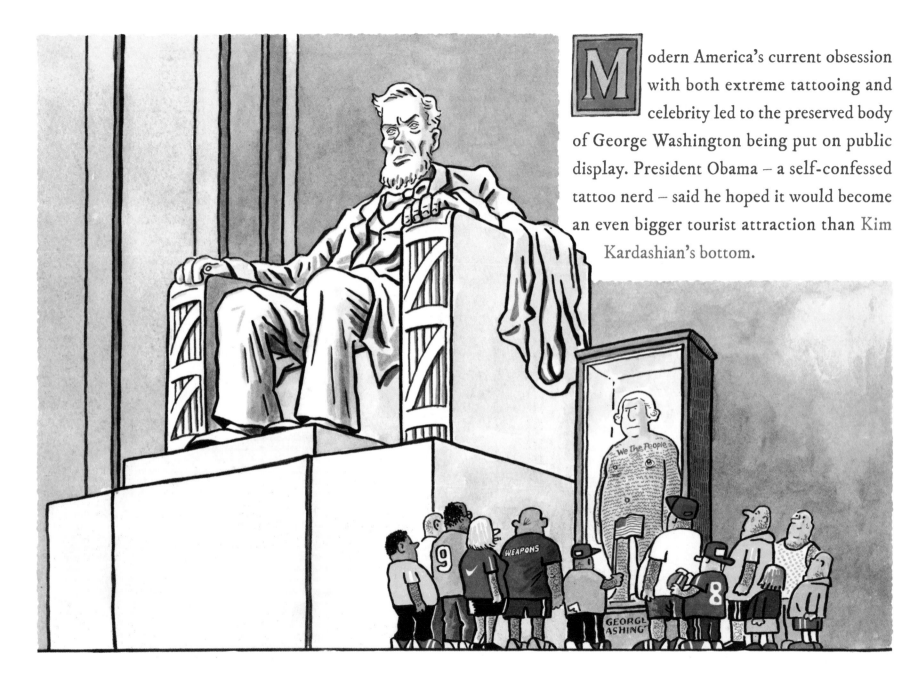

Modern America's current obsession with both extreme tattooing and celebrity led to the preserved body of George Washington being put on public display. President Obama – a self-confessed tattoo nerd – said he hoped it would become an even bigger tourist attraction than Kim Kardashian's bottom.

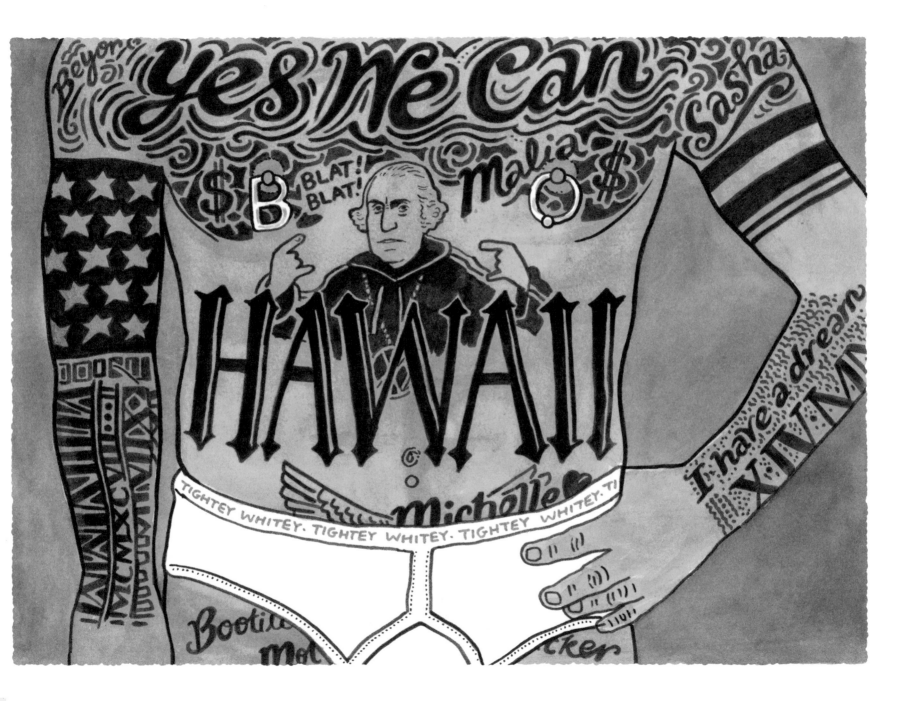

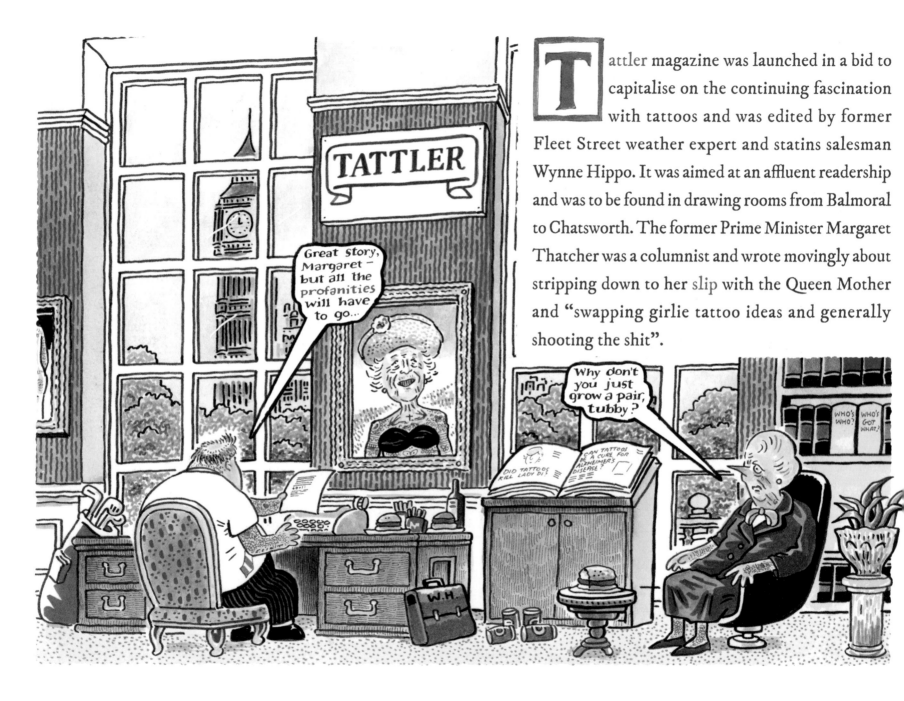

Tattler magazine was launched in a bid to capitalise on the continuing fascination with tattoos and was edited by former Fleet Street weather expert and statins salesman Wynne Hippo. It was aimed at an affluent readership and was to be found in drawing rooms from Balmoral to Chatsworth. The former Prime Minister Margaret Thatcher was a columnist and wrote movingly about stripping down to her slip with the Queen Mother and "swapping girlie tattoo ideas and generally shooting the shit".

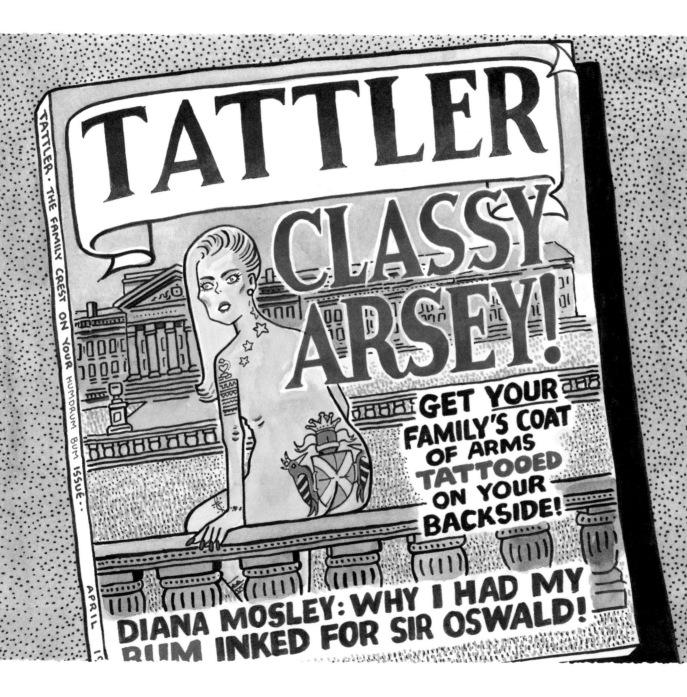

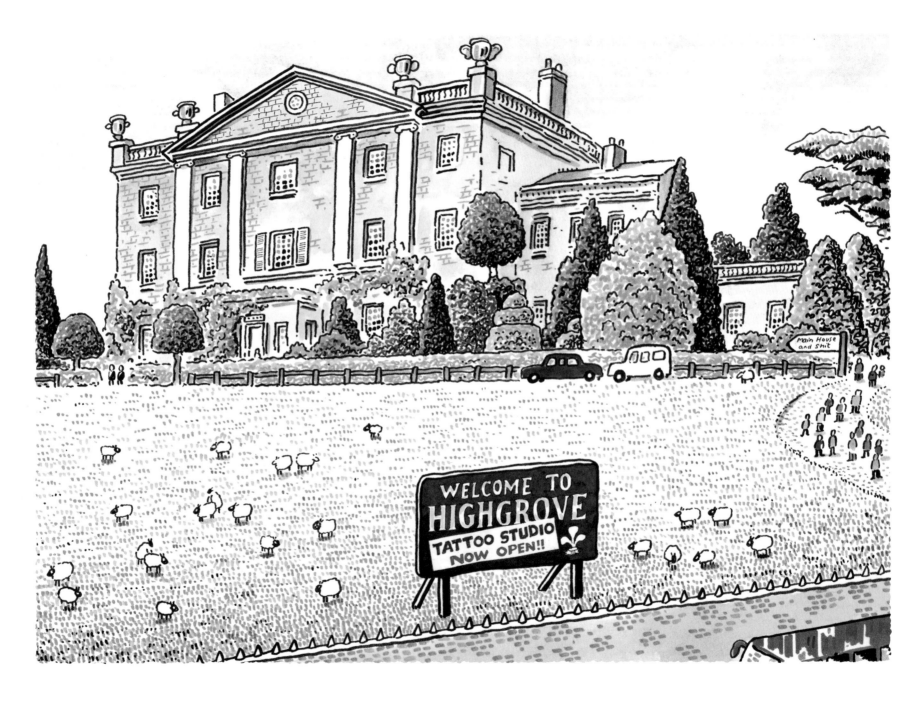

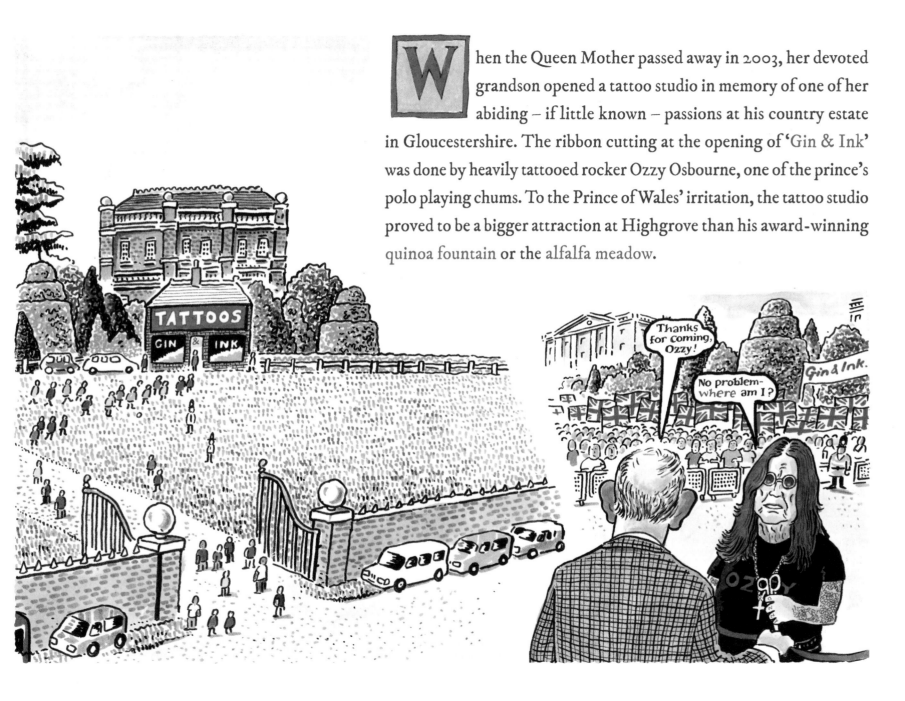

When the Queen Mother passed away in 2003, her devoted grandson opened a tattoo studio in memory of one of her abiding – if little known – passions at his country estate in Gloucestershire. The ribbon cutting at the opening of 'Gin & Ink' was done by heavily tattooed rocker Ozzy Osbourne, one of the prince's polo playing chums. To the Prince of Wales' irritation, the tattoo studio proved to be a bigger attraction at Highgrove than his award-winning quinoa fountain or the alfalfa meadow.

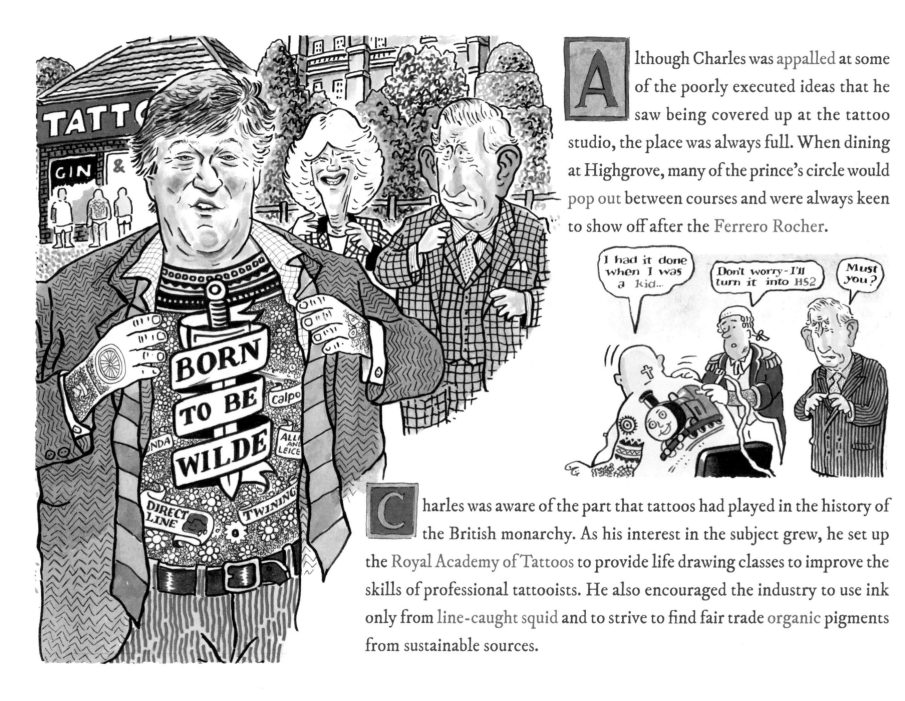

Although Charles was appalled at some of the poorly executed ideas that he saw being covered up at the tattoo studio, the place was always full. When dining at Highgrove, many of the prince's circle would pop out between courses and were always keen to show off after the Ferrero Rocher.

Charles was aware of the part that tattoos had played in the history of the British monarchy. As his interest in the subject grew, he set up the Royal Academy of Tattoos to provide life drawing classes to improve the skills of professional tattooists. He also encouraged the industry to use ink only from line-caught squid and to strive to find fair trade organic pigments from sustainable sources.

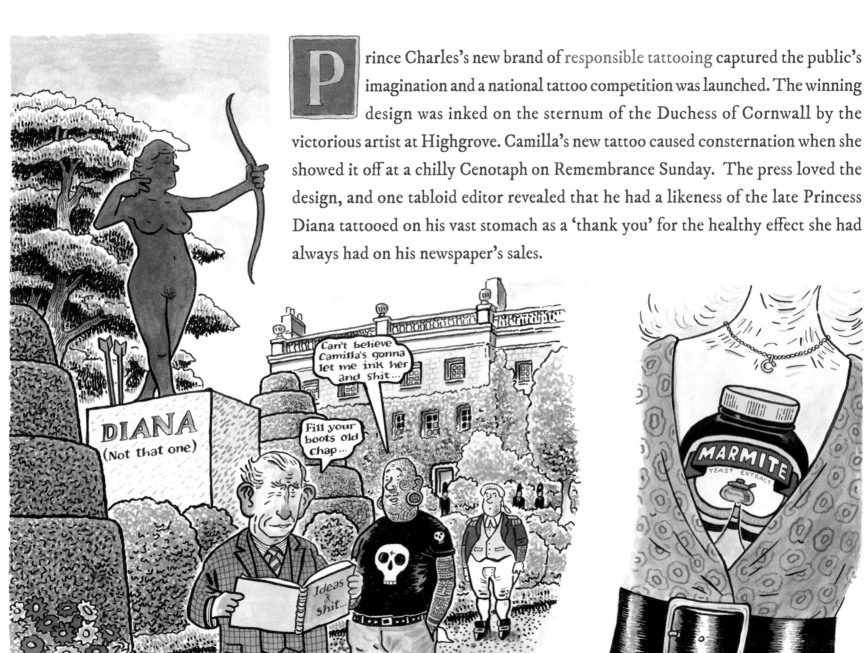

Prince Charles's new brand of responsible tattooing captured the public's imagination and a national tattoo competition was launched. The winning design was inked on the sternum of the Duchess of Cornwall by the victorious artist at Highgrove. Camilla's new tattoo caused consternation when she showed it off at a chilly Cenotaph on Remembrance Sunday. The press loved the design, and one tabloid editor revealed that he had a likeness of the late Princess Diana tattooed on his vast stomach as a 'thank you' for the healthy effect she had always had on his newspaper's sales.

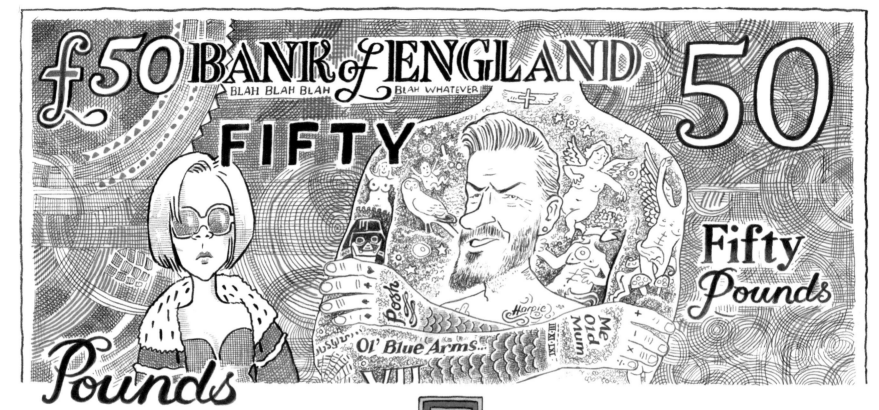

Tattoo studios in the Home Counties reported brisk business as women flocked to follow Camilla's lead, with pearl necklaces and horse-based paraphernalia being popular images. Queen Elizabeth announced her intention to abdicate on her 100th birthday. In her final Honours List, she ennobled the former footballer David Beckham for his long service to the UK's tattoo industry. Lord Beckham of Holland Park featured on a new £50 note (pictured).

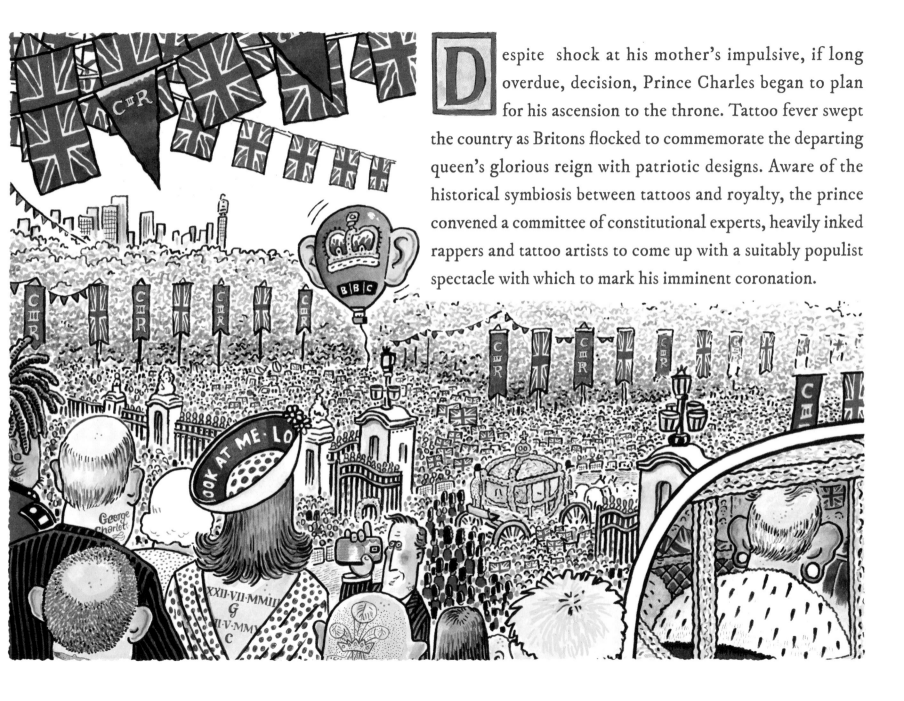

Despite shock at his mother's impulsive, if long overdue, decision, Prince Charles began to plan for his ascension to the throne. Tattoo fever swept the country as Britons flocked to commemorate the departing queen's glorious reign with patriotic designs. Aware of the historical symbiosis between tattoos and royalty, the prince convened a committee of constitutional experts, heavily inked rappers and tattoo artists to come up with a suitably populist spectacle with which to mark his imminent coronation.

C arefully leaked rumours that hip hop colossus Jay-Z had advised Charles to use the 'more blingy' House of Lords throne for the actual ceremony raised expectations for the occasion sky high. King Charles the Third was crowned in Westminster Abbey amid much pomp and fanfare. As the service was broadcast to a record worldwide audience, a solitary pin was heard to drop on the cold stone floor as the new king revealed his exquisitely decorated body. After announcing his intention to preside over "an Age of Ink", the new monarch and his blushing queen departed to a small tattooist's in Waterloo to have the date inked onto their coccyxes in case they forgot it.

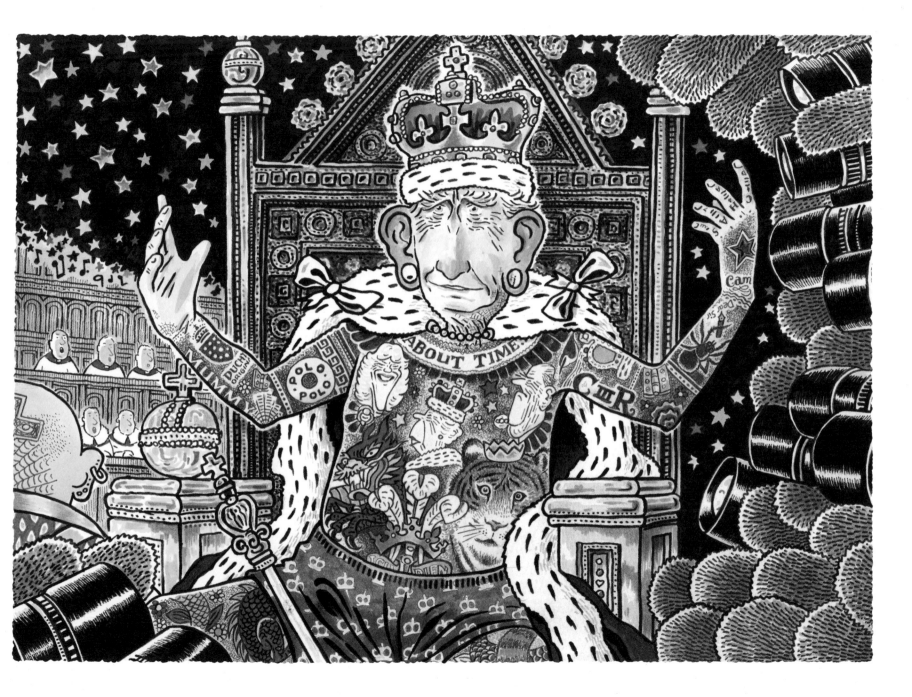